# FACE TIME

# FACE TIME

## PATRICK DE WILDE

Front cover: Mauritania, Tagani, Maure young woman of Berber ancestry
Back cover: Guatemala, Zunil Market, Quiche woman

Design: David Longuein

Project Manager, English-language edition: Magali Veillon
Editor, English-language edition: Brigitte Sion
Designer, English-language edition: Jessi Rymill
Production Manager, English-language edition: Colin Hough Trapp

Library of Congress Cataloging-in-Publication Data

Wilde, Patrick de, 1949-
  Face time : portraits of our family / Patrick de Wilde.
  p. cm.
  ISBN 0-8109-3081-1 (hardcover)
  1. Indigenous peoples--Portraits. 2. Portrait photography. 3. Wilde,
Patrick de, 1949- I. Title.

TR681.I58W55 2006
779'.2092--dc22
2006004761

Copyright © 2006 Éditions de La Martinière, Paris
English translation copyright © 2006 Abrams, New York

Printed and bound in France
10 9 8 7 6 5 4 3 2 1

HNA ▮▮▮▮▮
harry n. abrams, inc.
a subsidiary of La Martinière Groupe
115 West 18th Street
New York, NY 10011
www.hnabooks.com

*"**Man** is a mirror for man."*

› Maurice Merleau-Ponty

*"**If I differ from you,** far from causing you harm,
 I serve to better you."*

› Antoine de Saint-Exupéry

## For the past twenty-five years

I have crisscrossed the earth in search of images, encountering thousands of men and women, all different. I photographed some of them simply because they happened to be there, on the same faraway road. Through their individuality, they express the universal. I worked in communion with my subjects, both seeing and being seen, seeking a path to understanding. In these face-to-face encounters, where all is expressed in an instant—sometimes intensely—through a look more than through language, I captured expressions of dignity, tenderness, joy ... each playing its part in the composition of a singular, astonishing, human landscape.

## Working like a craftsman,

I would set up a makeshift studio as best as the circumstances allowed, often in precarious and even comical conditions— under the wing of an airplane, the cover of a tent, the hatchback of a Jeep, the porch of a temple, or the awning of a boat—searching in the flux of light and shadow to find a balance between the said and the unsaid. I wanted to show each individual without ornamentation and artifice, and I placed every subject in front of the same black cloth; I photographed them at twilight, under the assumption that people will reveal themselves more in the shadows than in bright light.

**in this way** I captured my subjects penetrating wisdom, kindness, and remarkable presence, different from what we encounter in the West. But although we humans all over the world are so different in our needs and perceptions, we also share the same humanity. It is this sameness and this diversity that I have tried to show—indeed, our essence is found in our diversity. As Nicholas of Cusa wrote in the middle of the fifteenth century, in his essay *On the Vision of God*:

> "In all faces the face of faces is seen veiled and in enigma. It is not seen unveiled so long as one does not enter into a certain secret and hidden silence beyond all faces where there is no knowledge or concept of a face. This cloud, mist, darkness, or ignorance into which whoever seeks your face enters when one leaps beyond every knowledge and concept is such that below it your face cannot be found except veiled. But this very cloud reveals your face to be there beyond all veils…."

**While most people** see it as an honor or find it fun to have their pictures taken, others are more reticent; some even fear that the camera will steal their soul. I see it as more of an enlargement than a kidnapping. While my photography may let me breach the intimacy of time, it does not allow me to halt it. The photos live on, shrouded in memories, like everything else. Breaking away from its auteur as well as its subject, a photograph will slowly take on an independent significance. A mere ten years after their creation, some photographs are no longer "shootable"—they show things that no longer exist. More than once, I have had the unfortunate experience of being the last witness to a tradition that has disappeared. Globalization works fast, erasing fundamental idiosyncrasies. If one of the roles of the artist is to bear witness to his era, allow me here to move beyond the boundaries of my profession and state, and express that happiness does not have much to do with economic development, and that our economic system deliberately fosters a confusion between the quality of life and standards of living. The market economy has imposed its pressures upon those living in wealthy countries in the same way that missionaries imposed their arrogance on "savages": by shaking their rattles. We are all "post-exotics"! We must remember this. Before television, rural European societies had traditions as rich as those of the people found in this book. Soon the differences between peoples around the world will disappear, and this will be seen by many as progress! I suspect, however, that the individual will become poorer, more vulnerable, and essentially sadder as a result of this grand unification. The

"other" is crucial in our own development, presenting a point of reference.

**Here is how** I would like my photographs to be read: as a testimony to the richness in our manifest differences and our perhaps less visible similarities; a declaration that our worth is found in the core of our being, in a spiritual force that ties us to our own structuring values, which is the foundation of our happiness. Researchers, philosophers, artists, and religious leaders dispute what constitutes Man. To address this question, I decided to include different opinions and convictions on this mystery, as a counterpoint to the photographs. It is maybe this very self-reflexive questioning that defines us. As the geneticist André Langaney writes, "We cannot establish categories—everything has mixed, bit by bit, and it is this mixture that has led to our genetic diversity today." This book is a free-flowing, haphazard journey through the diversity of faces and thoughts, a book with neither chapters nor even page numbers.

› Patrick De Wilde

The photographs in this book were produced using a silver process, which I chose not because I'm resistant to "progress" but because this method creates a complicity that goes beyond the image—as I tried to express—between the photographer and the subject. The challenge is to seize the moment!

→ Following pages
**Tanzania,** Serengeti, young circumcised Moran boys

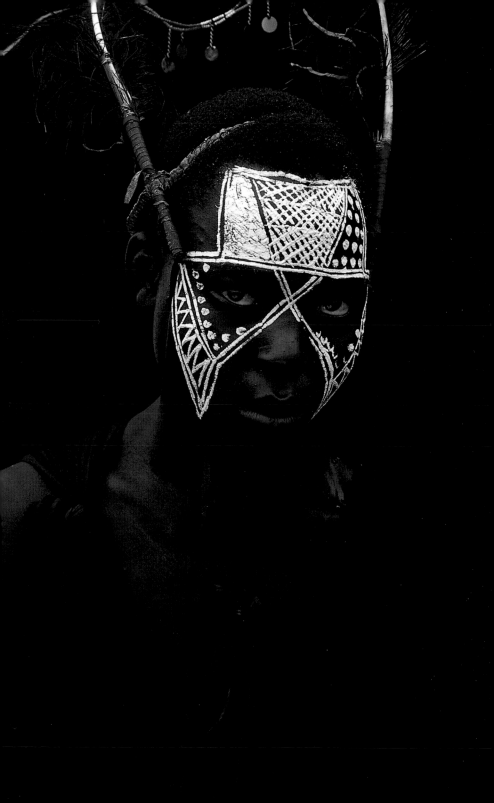

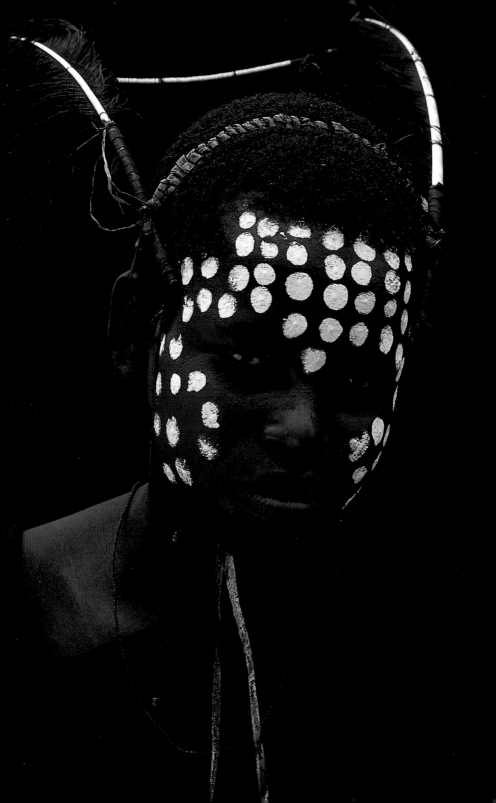

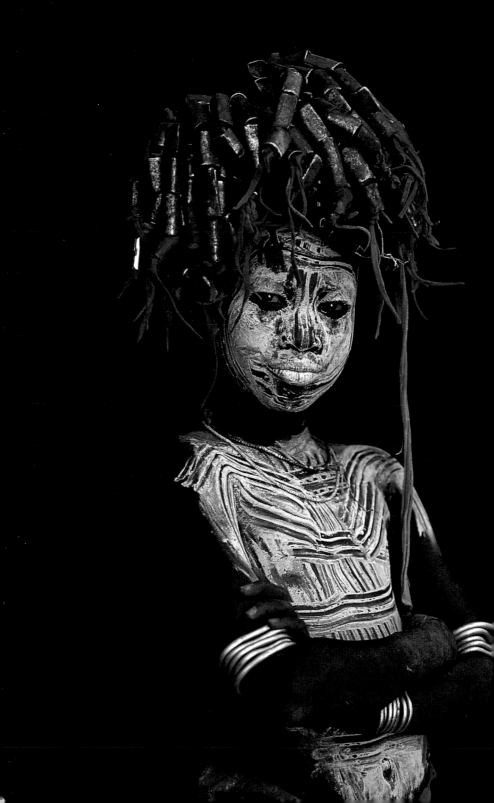

**We are forced to face the fact** that we never stop to ask ourselves what exactly defines man. We are quite happy just being it: there is in the mere fact of being a sort of self-evidence that dispenses with all definitions.

 A policeman perched on his small island was regulating the traffic with grave, slow solemnity.

"You," thought Sir Arthur, with a touch of tenderness, "you think: 'I'm a policeman. I regulate the traffic.' No doubt it also occurs to you to think: 'I am a British subject.' That again is a clear-cut notion. But how often in the course of your life have you said to yourself: 'I'm a human personality.' It would strike you as preposterous; but isn't that so because, above all, that idea's too vague, because you'd feel, if you were nothing but that, you were floating in mid-air?" The judge smiled: "I'm no different from him," he thought. "I think to myself: 'I'm a judge; I have to give right judgments.' If asked: 'What are you?' I too answer: 'A faithful subject of Her Majesty.' It's so much easier to define an Englishman, a judge, a Quaker, a Labor member, or a policeman, than to define a man pure and simple. [...] Our commands, our prohibitions are never founded on an irreducible bedrock. For all things human can, like chemical compounds, always be further and further reduced to other human components, short of ever reaching the one simple element: a definition of what is 'human.' That's the only thing we've never defined."

› **Jean Vercors**
*You Shall Know Them*

← Opposite
**Ethiopia,** Lower Omo Valley,
young Mursi girl

→ Following pages
**Ethiopia,** Lower Omo Valley,
Erbore children

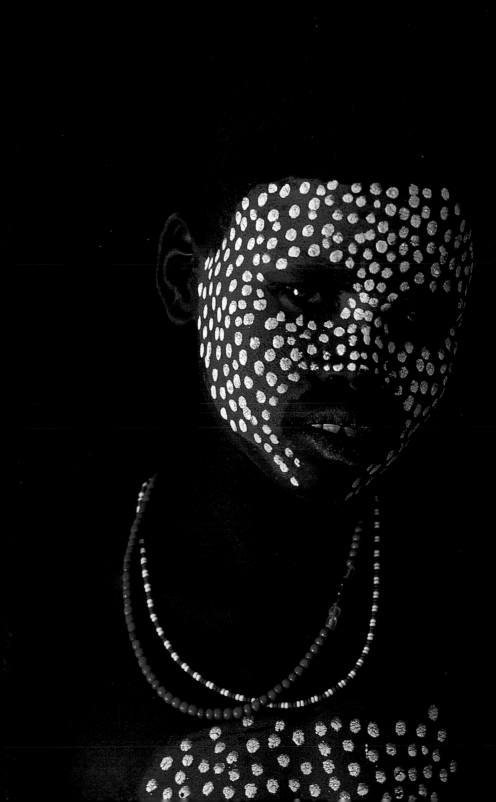

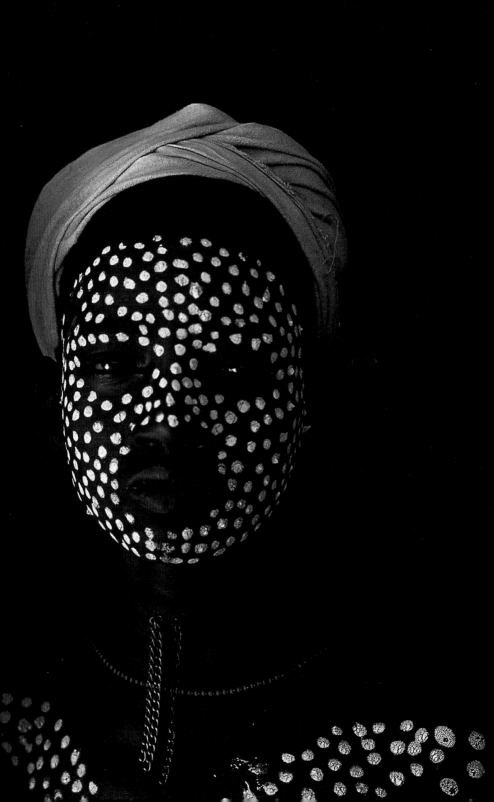

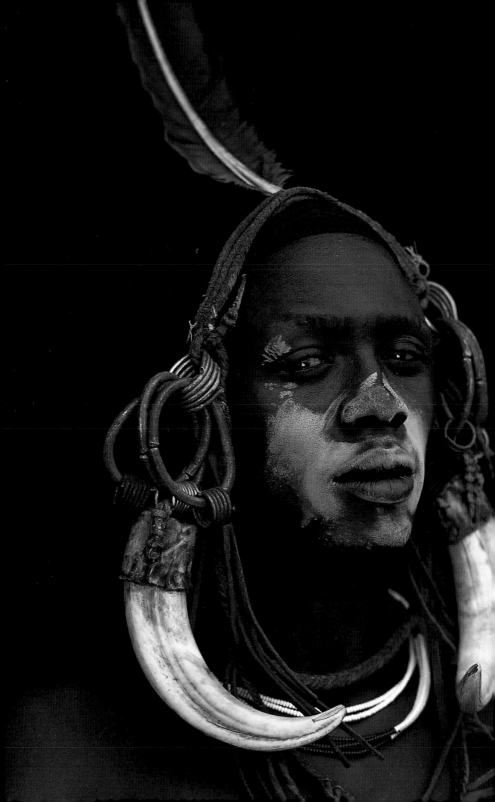

**Is it not the case** that art, whether it gives an account of things as they exist or depends essentially on the play of the imagination, has, as its ultimate function, to save us from disaster by creating, alongside the everyday world, another realm, fashioned according to the requirements of the human spirit and in keeping with an inner order which, by its very nature, is in sharp contrast to the unbelievable muddle of the reality around us? This being so, the artist, once we admit that his activity goes beyond mere entertainment, could be said to find his *raison d'être* in the very existence of the chaos in which we flounder.

› **Michel Leiris**
*Francis Bacon*

← Opposite
**Ethiopia,** Omo Valley,
Mursi warrior

→ Following pages
**Ethiopia,** Lower Omo Valley,
Dassanetch woman from the
Turkana (left); Mursi woman
with a lip plate (right)

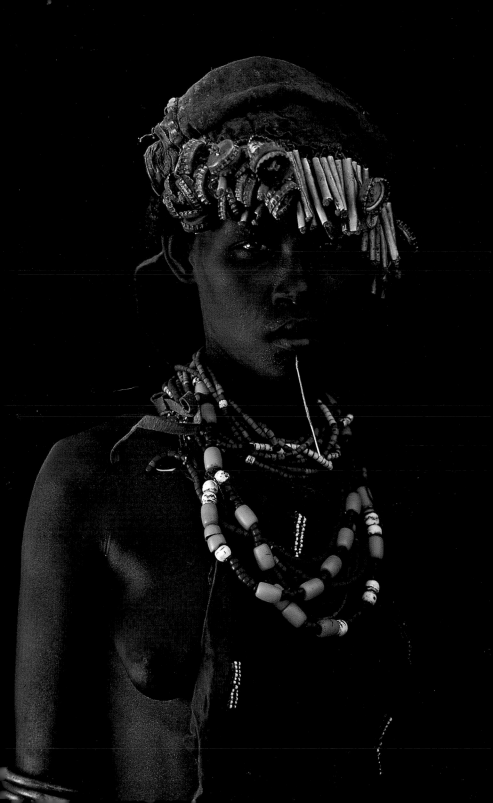

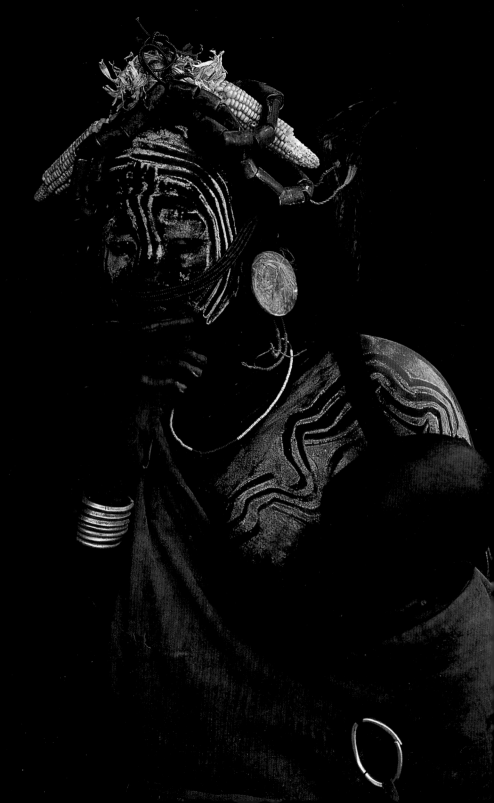

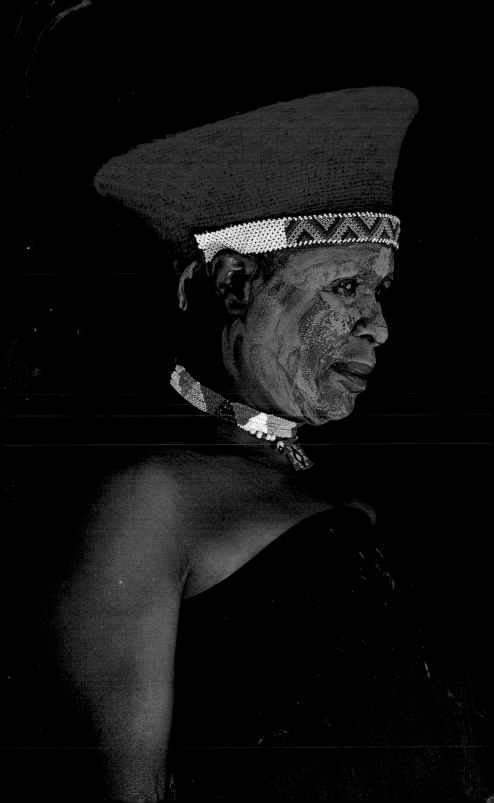

**Had me and humans** first come to be hundreds of even thousands of years ago, we might know most of what's important about our past. There might be very little of significance about our history that's hidden from us. Our reach might extend easily to the beginning. But instead, our species is hundreds of thousands of years old, the genus Homo millions of years old, primates tens of millions of years old, mammals over 200 million years old, and life about four billion years old. Our written records carry us only a millionth of the way back to the origin of life. Our beginnings, the key events in our early development, are not readily accessible to us. No first-hand accounts have come down to us. They cannot be found in living memory or in the annals of our species. Our time–depth is pathetically, disturbingly shallow. The overwhelming majority of our ancestors is unknown to us. They have no names, no faces, no foibles. No family anecdotes attached to them. They are irreclaimable, lost to us forever.

› **Carl Sagan and Ann Druyan**
*Shadows of Forgotten Ancestors*

← Opposite
**South Africa,** Zululand,
Zulu woman

→ Following pages
**Namibia,** Kaokoland,
Himba woman and child

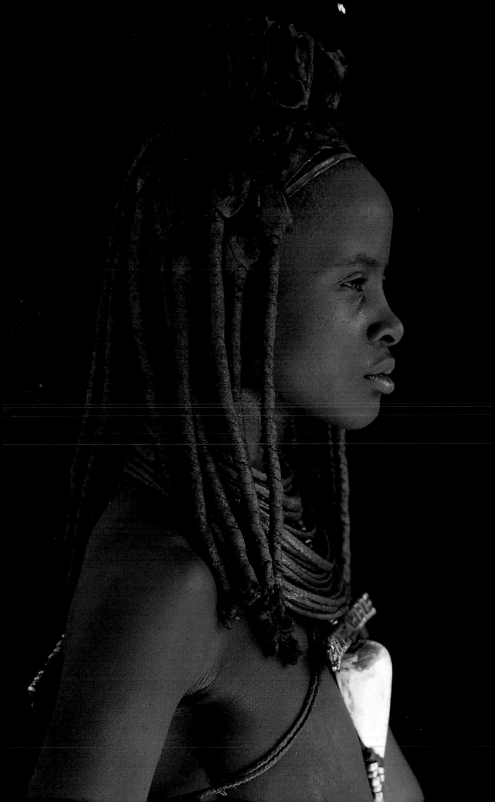

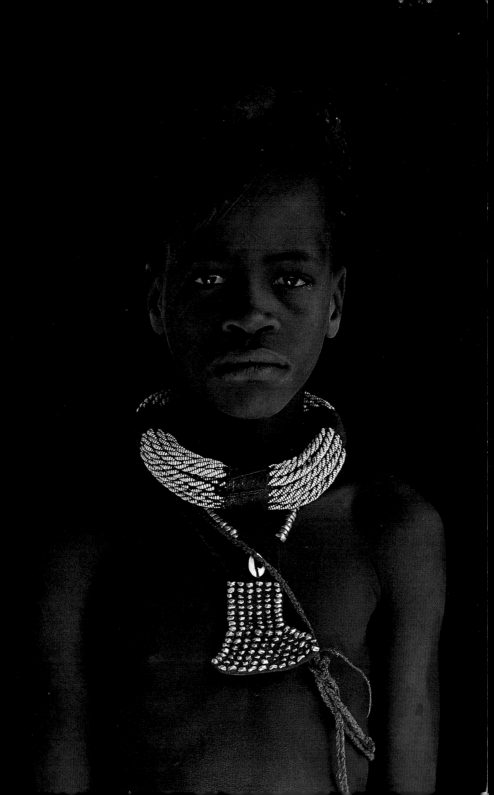

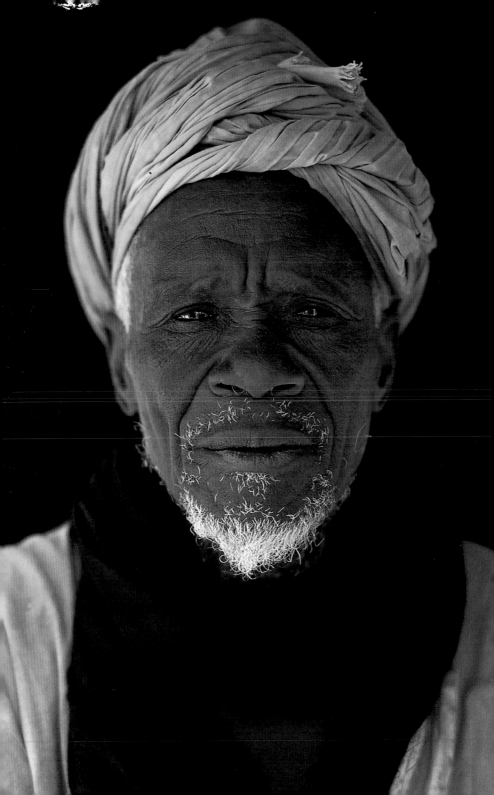

**Encounter with the other** intensifies awareness of one's own cultural identity. This principle explains the anthropologist's insistence on fieldwork in a new alien setting, and it explains his use of comparison between the foreign and the familiar. The fish is the last to understand the water. Perhaps he can do so in contrast to the land. Some kind of encounter with an other is necessary to grasp the power and reality of culture.

› **James L. Peacock**
*The Anthropological Lens*

← Opposite

**Mauritania,** Tagani, Maure man of Berber ancestry

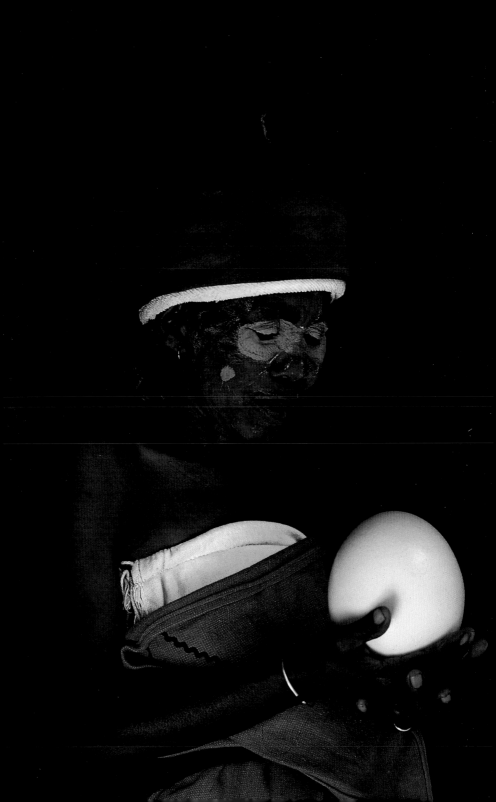

# What finer gift can another person give

us than to reinforce our feeling of uniqueness and originality by being different from us? Instead of attempting to smooth over conflicts and blot out confrontations, we should realize that these conflicts and confrontations must and can be of benefit to us all.

This is possible provided that the aim is neither the destruction of the other person nor the establishment of a hierarchy, but the gradual construction of each individual. The clash, even though violent, is beneficial; it allows each one to reveal himself in his singularity. Competition, which is, on the contrary, almost always insidious, is destructive; it can only lead to each one being locked into an imposed order, a necessarily artificial and arbitrary hierarchy.

The first lesson of genetics is that individuals are all different and cannot be classified, evaluated, or placed on a hierarchy: the definition of "races," which is useful in some kinds of research, cannot fail to be arbitrary and imprecise. [...] When the quality of human relationships and of social harmony in certain groups that we call "primitive" is taken into consideration, the wisdom of imitating our culture seems highly questionable, and one wonders if it will not lead to catastrophe. The price paid for the improvement in the standard of living is terribly high.

› **Albert Jacquard**
*In Praise of Difference*

← Opposite
**South Africa,** Republic of
Transkei, Xhosa woman

→ Following pages
**Mali,** Timbuktu,
Peul woman

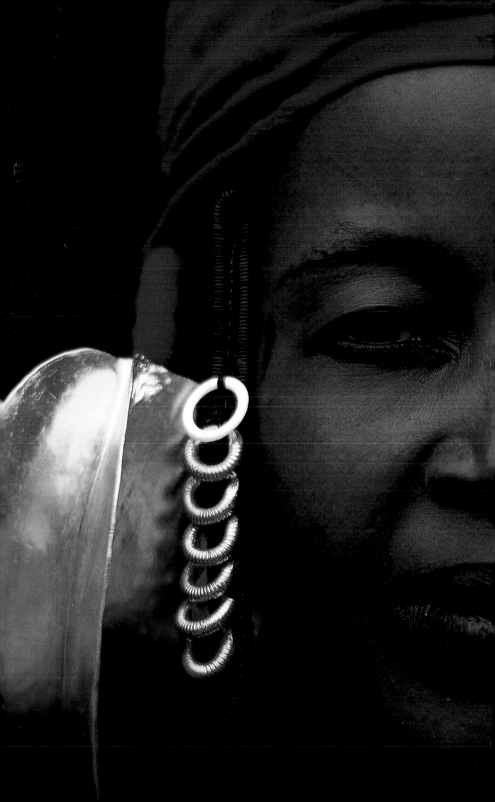

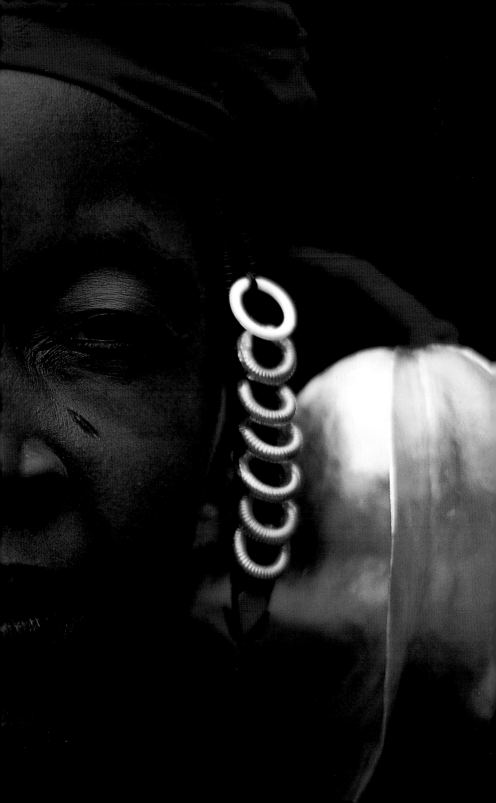

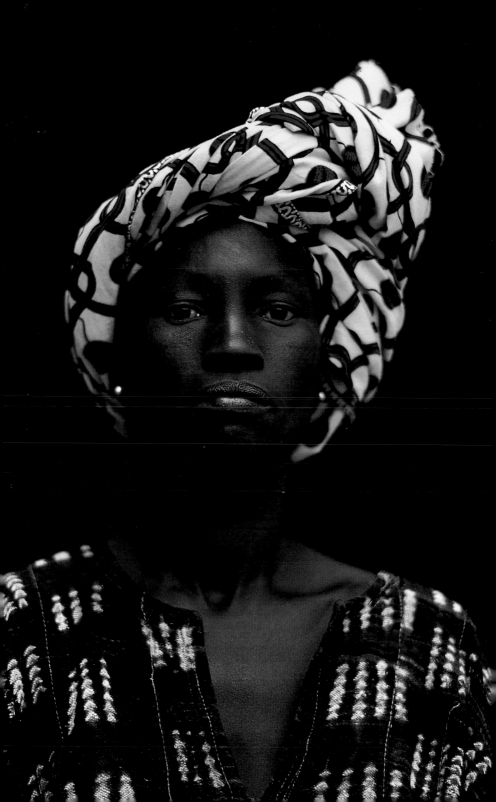

**The true contribution of a culture** consists, not in the list of inventions which it has personally produced, but in its difference from others.  There is not, and can never be, a world civilization in the absolute sense, since civilization implies the coexistence of cultures exhibiting the maximum possible diversities. A world civilization could, in fact, represent no more than a worldwide coalition of cultures, each of which would preserve its own originality.

› Claude Lévi-Strauss
*Race and History*

→ Following pages

← Opposite
**Mali,** Tireli,
Dogon woman

**Tanzania,** Olduvai Valley, Masai woman (left); **Kenya,** Mount Kenya Shaba, Samburu woman (right)

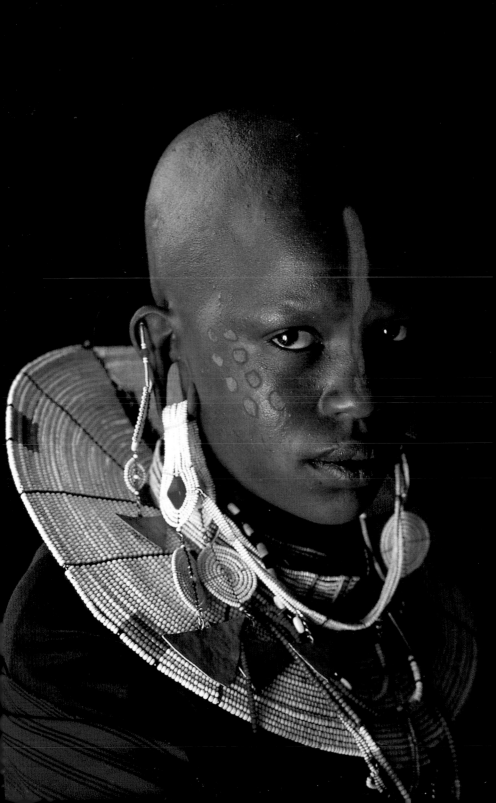

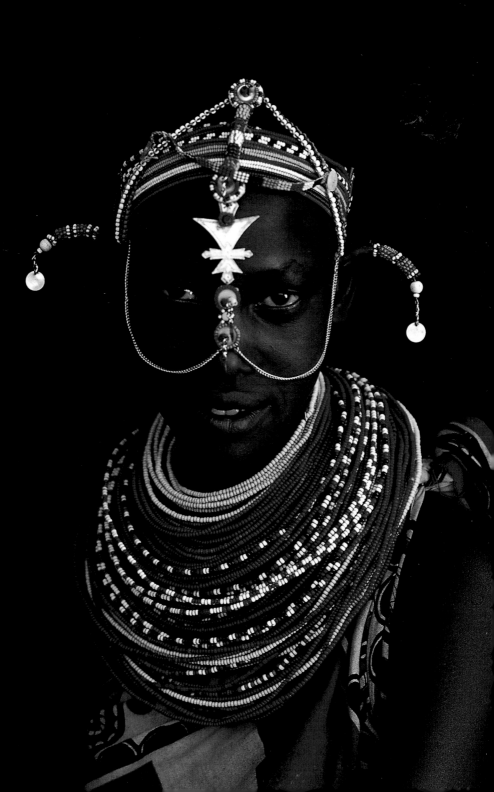

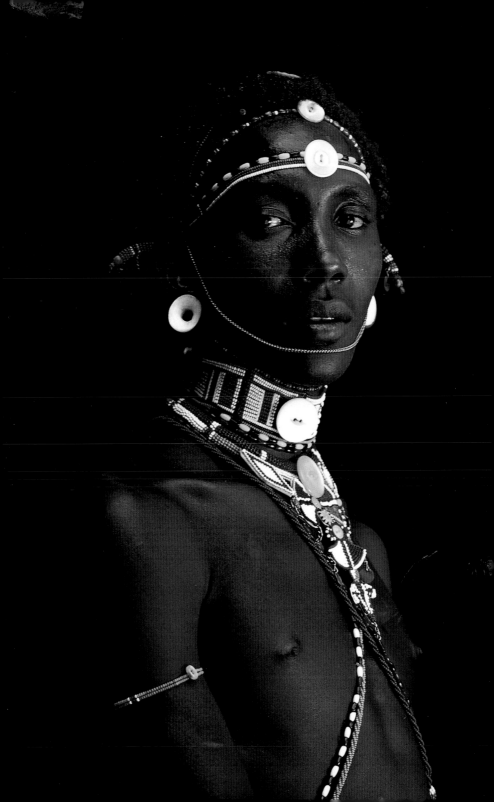

**Ethnologists and anthropologists** are the only people who can tell us of the diversity of the cultures they observe directly, and hence of the common points that unite them over and above their many differences. Unanimous in proclaiming the universality of the prohibition of incest, they are no less unanimous in stressing the universality of the sexual division of roles. [...] We know of no culture that has said, articulately, that there is no difference between men and women except in the way they contribute to the procreation of the next generation; that otherwise in all respects they are simply human beings with varying gifts, no one of which can be exclusively assigned to either sex. [...]

There are many African legends that evoke the original separation of the sexes, a radical separation since it is both geographical and economic. Thus in Kenya, the Masai related that in the beginning, men and women formed two separate tribes who lived apart. The women bred antelopes, the men cattle.

› **Elisabeth Badinter**
*Man/Woman: The One Is the Other*

← Opposite
**Kenya,** Ewaso Nyiro,
young Samburu warrior.

→ Following pages
**Kenya,** Lake Natron,
Samburu man.

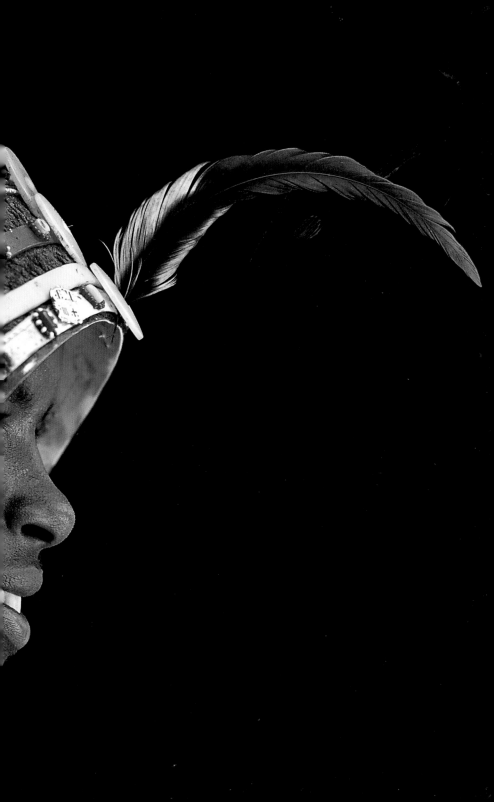

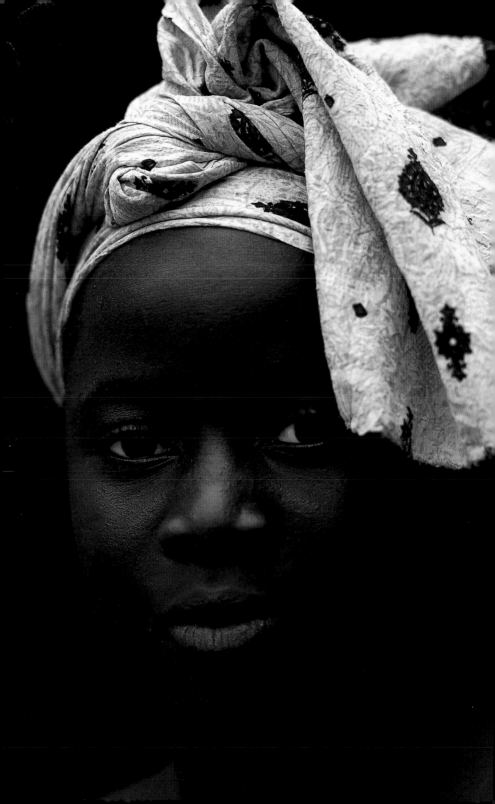

**We feel ourselves no longer isolated** in humanity; humanity no longer seems isolated in the nature that it dominates. As the smallest grain of dust is bound up with our entire solar system, drawn along with it in that undivided movement of descent which is materiality itself, so all organized beings, from the humblest to the highest, from the first origins of life to the time in which we are, and in all places as in all times, do but evidence a single impulsion, the inverse of the movement of matter, and in itself indivisible. All the living hold together, and all yield to the same tremendous push. The animal takes its stand on the plant, man bestrides animality, and the whole of humanity, in space and in time, is one immense army galloping beside and before and behind each of us in an overwhelming charge able to beat down every resistance and clear the most formidable obstacles, perhaps even death.

› **Henri Bergson**
*Creative Evolution*

← Opposite
**Mali,** Bou Djebeha, young Peul girl

→ Following pages
**Tanzania,** Zanzibar, Swahili woman (left); **Mauritania,** Tagant, young Maure girl (right)

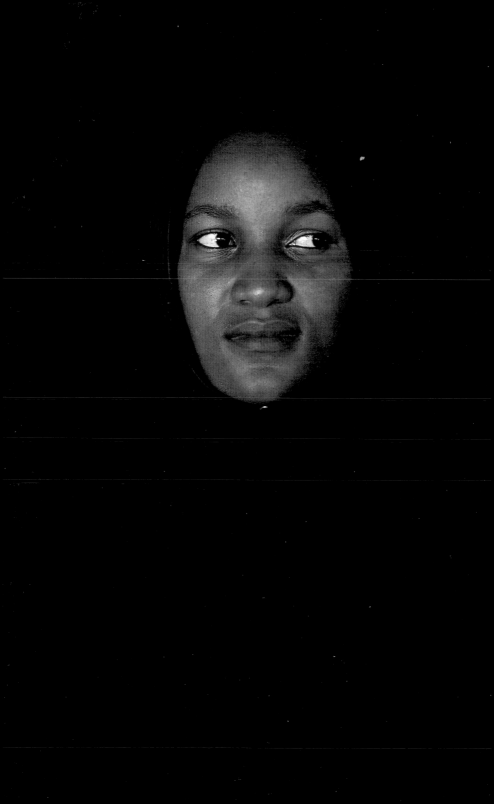

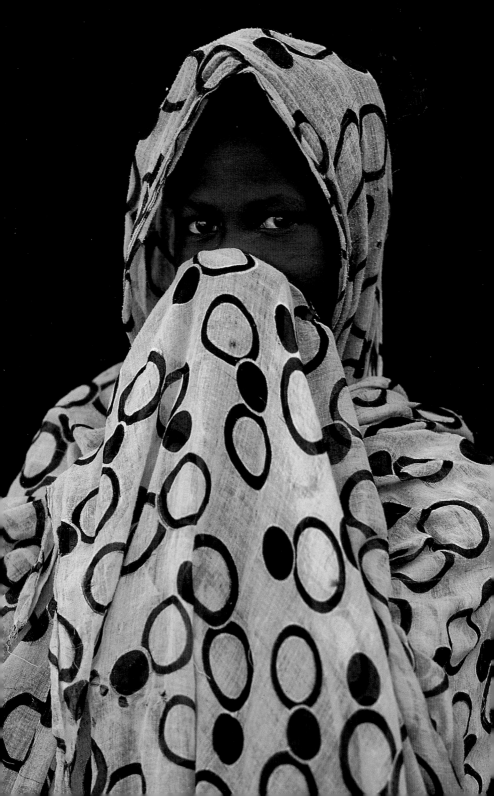

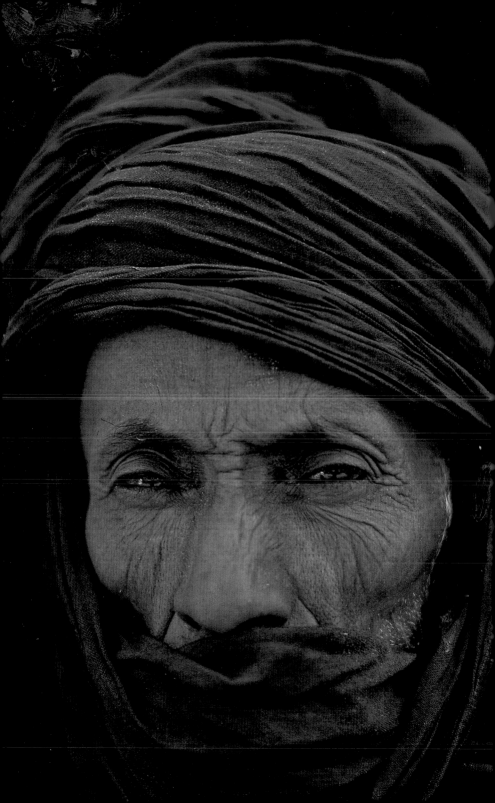

**Heritage is not lost and found,** stolen and reclaimed. Despite a discourse of conservation, preservation, restoration, reclamation, recovery, re-creation, recuperation, revitalization, and regeneration, heritage produces something new in the present that has recourse to the past. Such language suggests that heritage is there prior to its identification, evaluation, conservation, and celebration. [...] Heritage adds value to existing assets that have either ceased to be viable (subsistence lifestyles, obsolete technologies, abandoned mines, the evidence of past disasters) or that never were economically productive because an area is too hot, too cold, too wet, or too remote. [...] It does this by adding the value of pastness, exhibition, difference, and, where possible, indigeneity.

› **Barbara Kirshenblatt-Gimblett**
*Destination Culture*

← Opposite

**Sahara,** Mali desert,
Tuareg nomad

→ Following pages

**Sahara,** Arouane,
Tuareg women

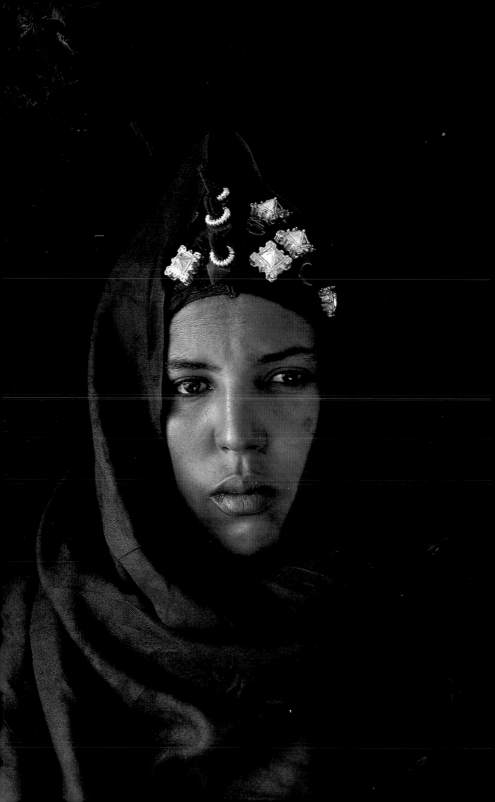

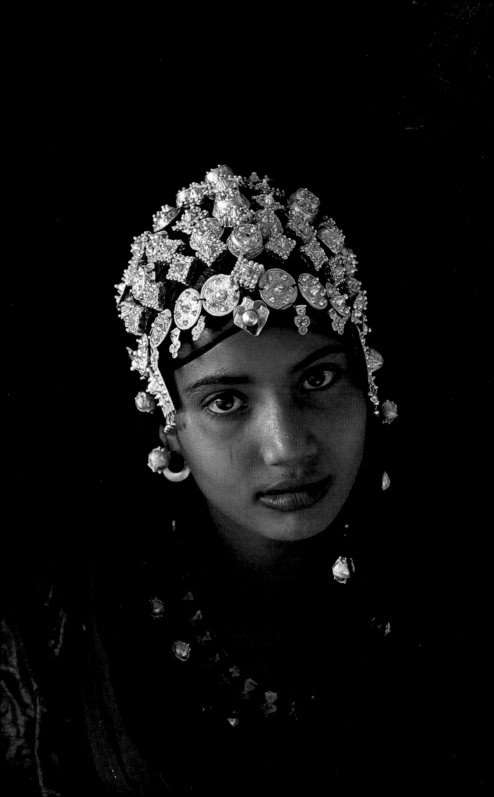

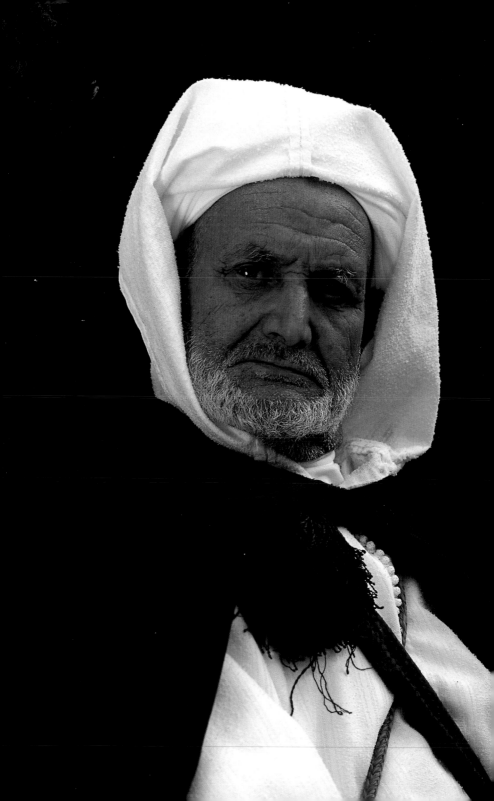

**Conformity and stability** are inseparably connected. Non-conformity breaks the force of tradition. Conformity to instinctive activities is enforced by our organic structure, conformity to automatic actions by habit. The infant learns to speak by imitation. During the first few years of life the movements of the larynx, tongue, roof of the mouth, and lips are gradually controlled and executed with great accuracy and rapidity. [...] Early habits control also the movements of the body. In childhood we acquire certain ways of handling our bodies. If these movements have become automatic it is almost impossible to change to another style, because all the muscles are attuned to act in a fixed way. To change one's gait, to acquire a new style of handwriting, to change the play of the muscles of the face in response to emotion is a task that can never be accomplished satisfactorily.

› **Franz Boas**
*Anthropology and Modern Life*

← Opposite
**Morocco,** Atlas,
Berber man

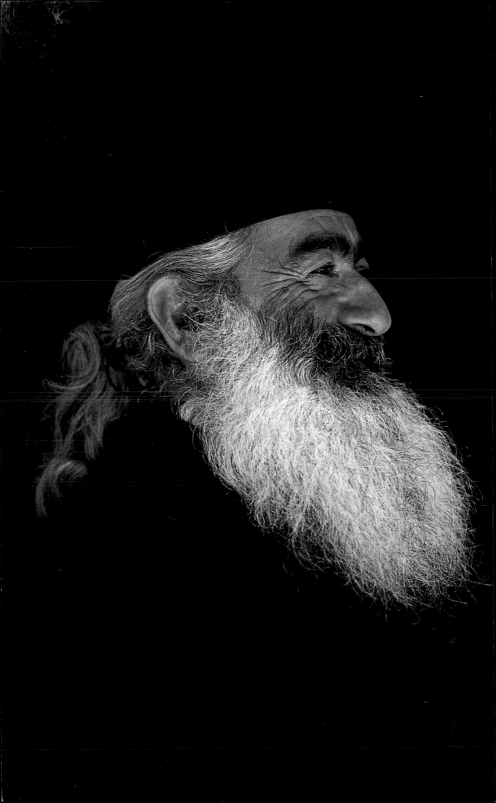

**To place human evolution** in a time perspective, recall that life originated on Earth several billion years ago and that the dinosaurs became extinct around 65 million years ago. It was only between six and ten million years ago that our ancestors finally became distinct from the ancestors of chimps and gorillas. Hence human history constitutes only an insignificant portion of the history of life.

› **Jared Diamond**
*The Third Chimpanzee*

← Opposite
→ Following pages

**Greece,** Ithaca,
Orthodox priest

**Uzbekistan,** Samarkand,
Tajik man

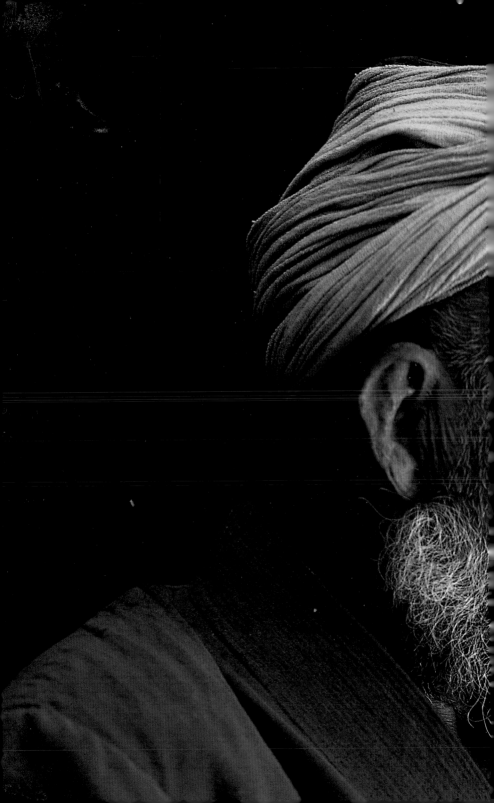

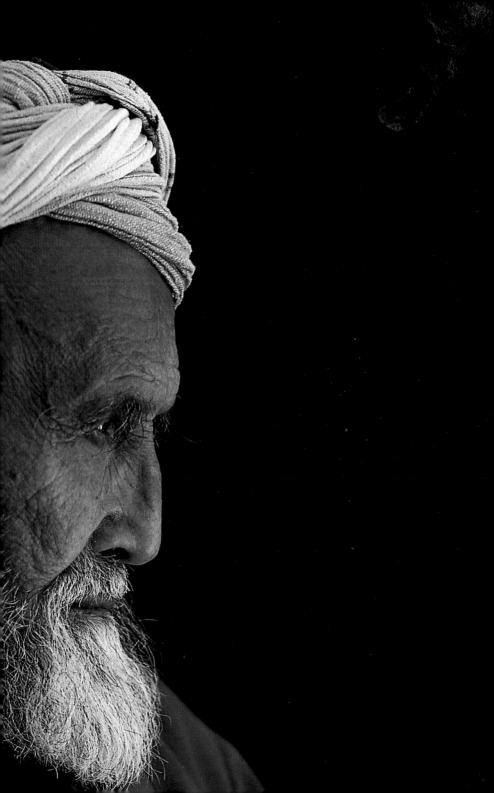

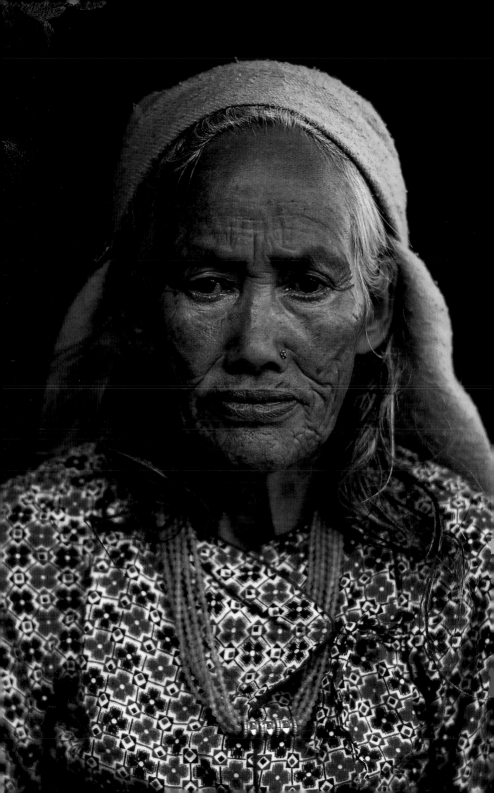

**There are values that concern** the whole human race without exception. And these values come before all else. Traditions deserve to be respected only insofar as they are respectable—that is, exactly insofar as they themselves respect the fundamental rights of men and women. [...] Humanity, while it is also multiple, is primarily one. [...] At the same time as we fight for the universality of values it is imperative that we fight against the impoverishment of standardization; against hegemony, whether ideological, political, economic, or operating in the media; [...] against everything that stifles the full variety of linguistic, artistic, and intellectual expression. Against everything that makes for a monotonous and puerile world.

› **Amin Maalouf**
*In the Name of Identity*

← Opposite
**Nepal,** Pokhara Valley,
Magar woman

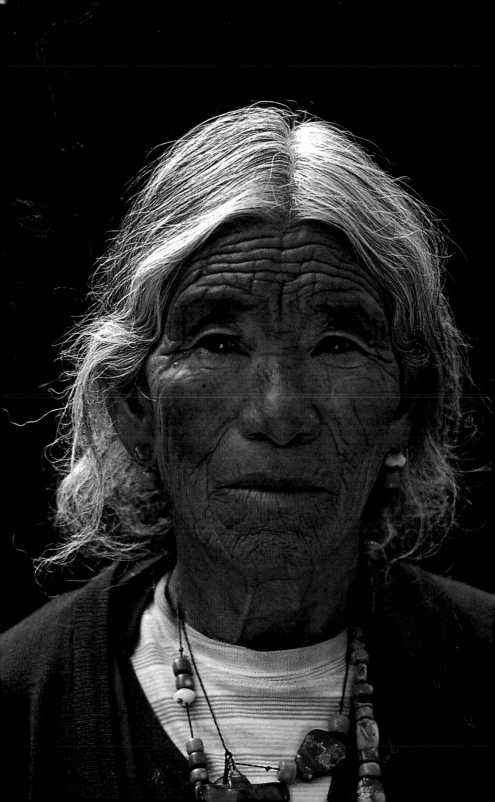

**The idea of underdevelopment** ignores the possible qualities and advantages of millennial cultures, which are—or were—part of so-called underdeveloped populations. It thereby plays a major role in dooming these cultures, which it considers as consisting of many superstitions. Arrogant alphabetization, which does not recognize the oral base of these cultures, but sees them as merely illiterate, only worsens the moral and mental underdevelopment. There is certainly no point in idealizing cultures other than our own. All cultures, including our own, are a hodgepodge of superstitions, fictions, obsessions, uncritically accumulated knowledge, glaring errors, and profound truths. Yet such a mix is not readily discernible, and one should be wary of classifying millennial knowledge as superstition. [...] Development is indeed a goal, but we should stop making it a myopic or terminal goal. Development as a goal serves other purposes, namely, true living, better living. A living that includes understanding, fellowship, and compassion.

› **Edgar Morin**
*Homeland Earth*

← Opposite
**Nepal,** Patan,
Tibetan refugee

→ Following pages
**Nepal,** Kathmandu Valley,
Newar man and woman

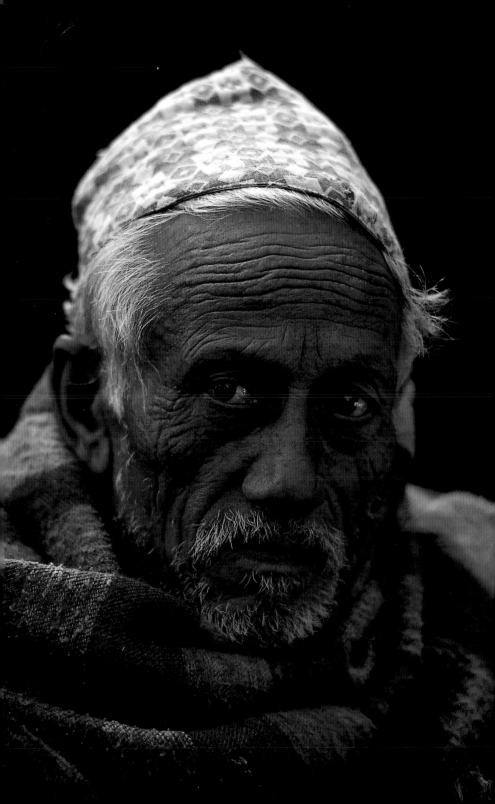

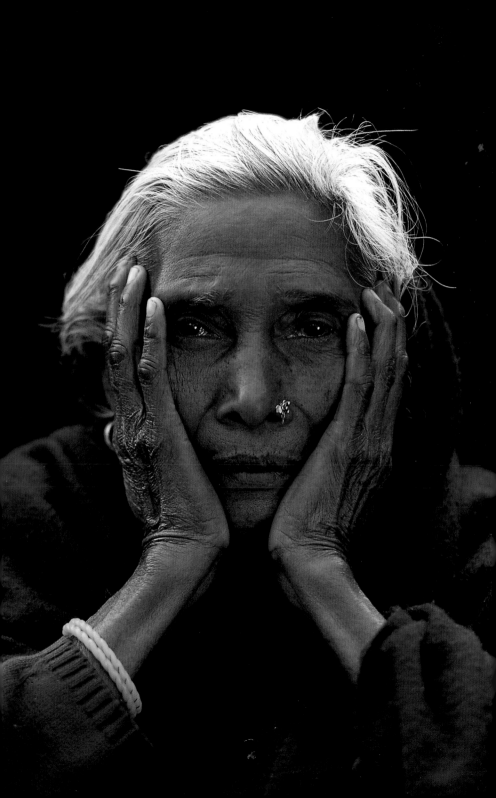

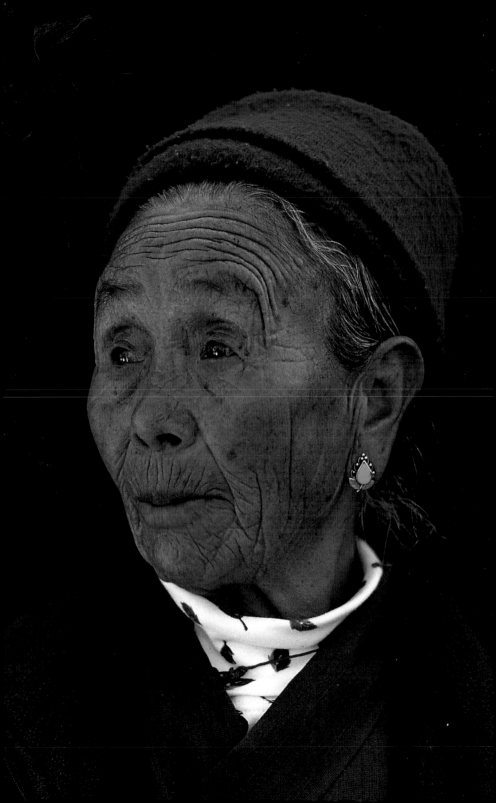

**Our will is infinite,** while our intelligence is finite; we follow experience pretty closely in our ideas of things, and even the furniture of fairyland bears a sad resemblance to that of earth; but there is no limit to the elasticity of our passion; and we love to fancy ourselves kings and beggars, saints and villains, young and old, happy and unhappy. There seems to be a boundless capacity of development in each of us, which the circumstances of life determine to a narrow channel; and we like to revenge ourselves in our reveries for this imputed limitation, by classifying ourselves with all that we are not, but might so easily have been.

› **George Santayana**
*The Sense of Beauty*

**Nepal,** Kathmandu Valley, Tibetan refugee

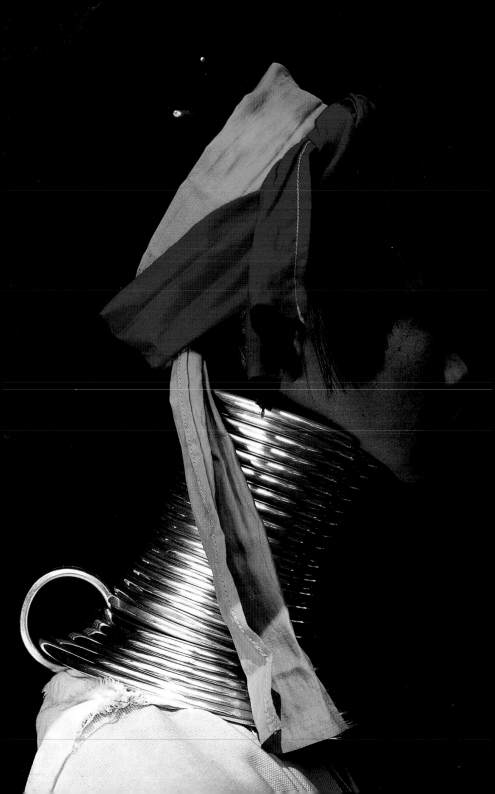

**The human being** is therefore that strange animal who has no real identity at first, but who spends his life producing one: he converts form into substance, fortune into nature, habit into essence. [...] At the outset man is, of course, diverse and undulating, and the confrontation of his different aspects can take the place of company; but the course of human life leads everyone to discover his ruling quality, and to stick by it. [...] Nature doesn't determine in advance what each man or each people will become; chance, liberty, and will each have its place. [...] Man belongs not only to a cultural context; all of life unfolds in time, so he has an individual history as well. The outcome of life is the identity of the person. That "essence" is the product of existence, not of its source. [...] The striking consequence of this discovery is that man becomes more and more authentic as he ages: life is a process of becoming oneself.

› Tzvetan Todorov
*Imperfect Garden: The Legacy of Humanism*

← Opposite
**Myanmar,** Karen,
Padaung woman

→ Following pages
**Thailand,** Golden Triangle,
Me La, young Karen girl (left);
**Thailand,** Sam Yiek,
young Akha girl (right)

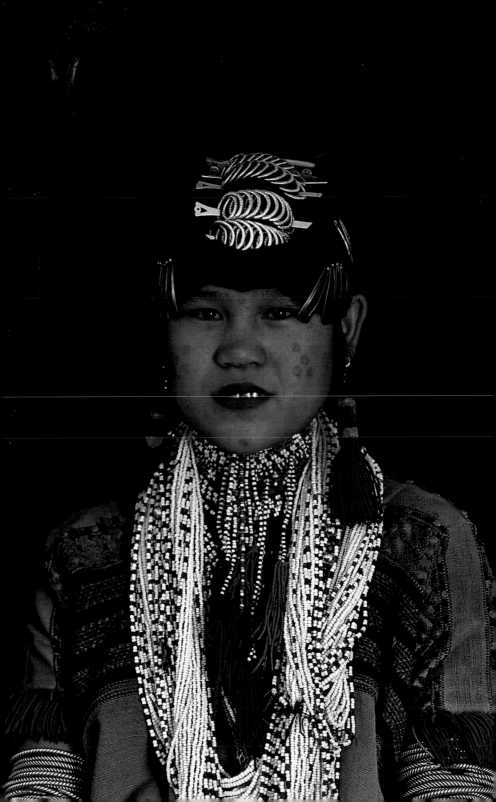

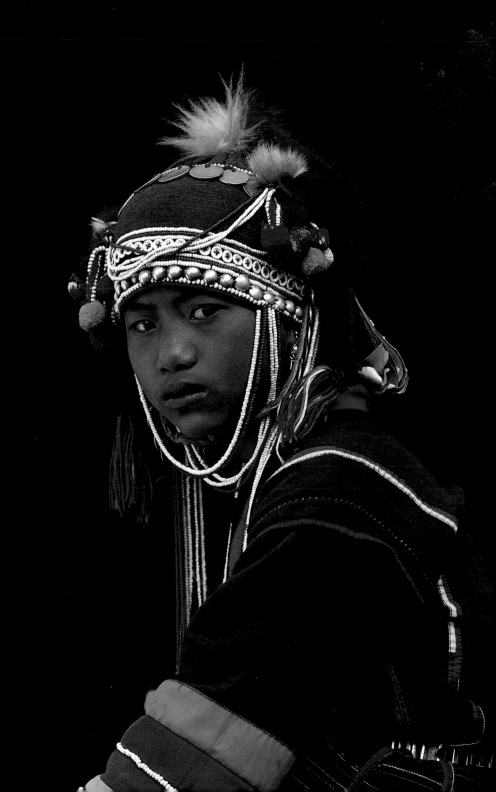

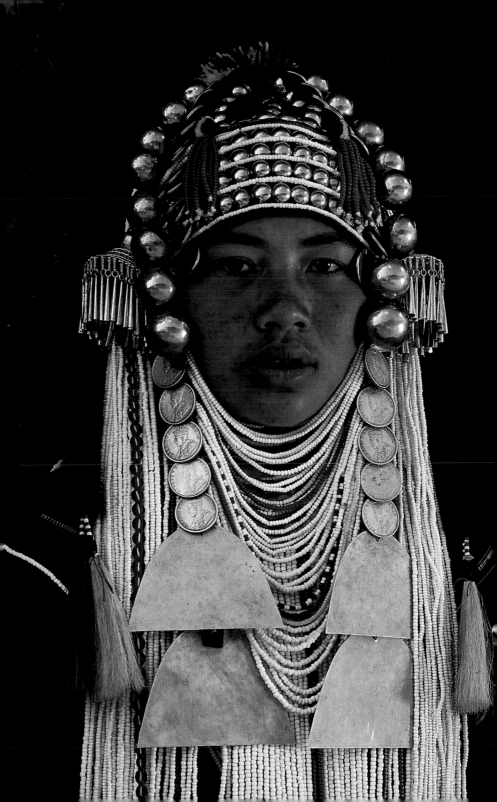

**In the very name** of Western humanism, we may still retain certain reservations about "one world," however fraternal. The infinite variety of mankind may be, on the cultural as well as the genetic level, the necessary condition for its survival. Who knows whether the cultures now being denied and derided do not possess the specific features best fitted to meet the challenge of tomorrow. The impoverishment of the cultural inheritance of mankind, for which the West is largely responsible, would then have caused incalculable damage; it is not at all certain that cultural difference could adapt to any meaningful extent to real universalism.

› **Serge Latouche**
*The Westernization of the World*

← Opposite
**Thailand,** Golden Triangle,
young Akha man

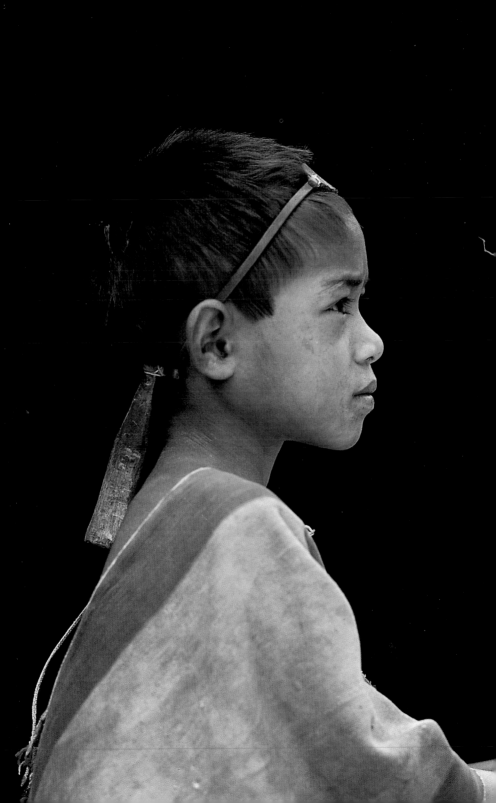

**Living objects all share** four attributes: they can produce offspring, they have a history of common descent from shared ancestors, they are made of invisible soft building blocks called cells, and each cell carries within itself a singular chemical, or DNA. [...] It has taken us a long time to see that the first three attributes are consequences of the fourth: of all the molecules in every cell, DNA alone unites all life in a common history, because every cell of every living thing has for about the past four billion years contained a version of DNA. [...]

Human genomes are plentiful but fleeting. At the conception of every child, a distinctly different human genome is bound and issued for the first and only time. There are as many human genomes as there are persons: six billion drafts of the human DNA text are clustered over every part of the planet not covered by water.

› **Robert Pollack**
*Signs of Life*

→ Following pages
**Mongolia,** Kogo Kan, Buriat woman cattle farmer (left);

← Opposite
**Thailand,** Golden Triangle, Me La, Karen child

**Mongolia,** Tengis Valley, Siberian shaman (right)

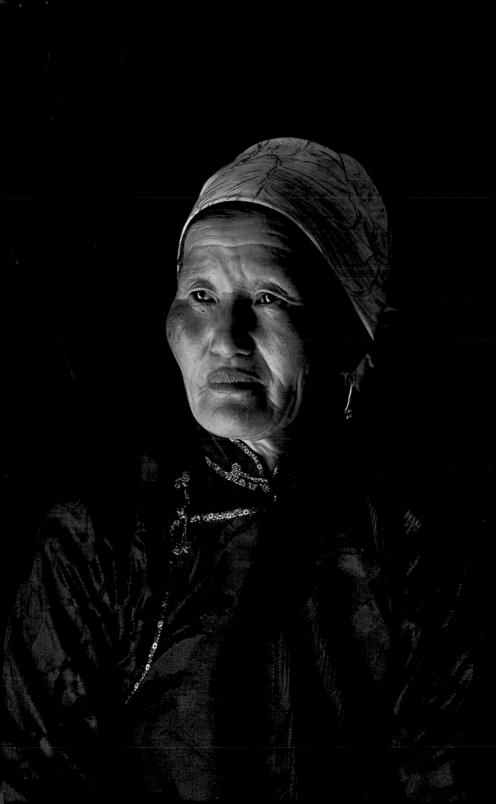

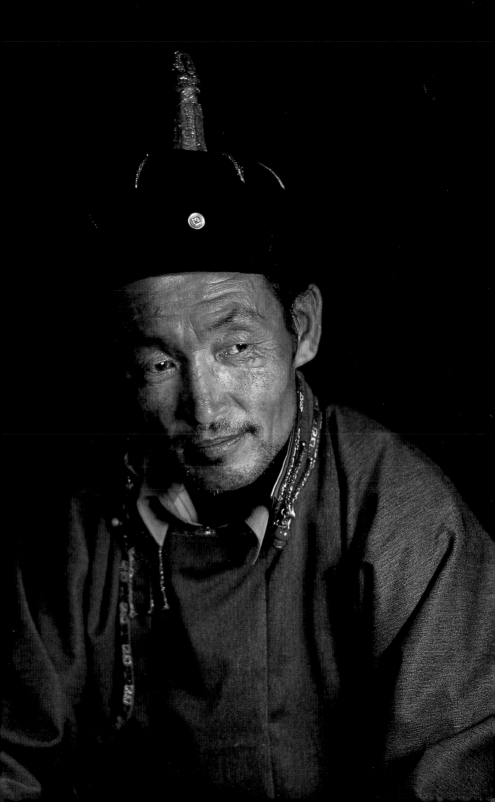

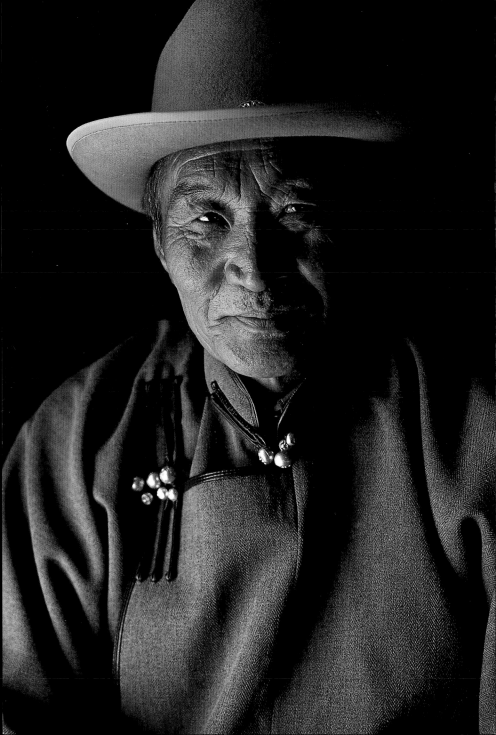

**We are incomplete** or unfinished animals who complete or finish ourselves through culture—and not through culture in general but through highly particular forms of it: Dobuan and Javanese, Hopi and Italian, upper-class and lower-class, academic and commercial. Man's great capacity for learning, his plasticity, has often been remarked, but what is even more critical is his extreme dependence upon a certain sort of learning: the attainment of concepts, the apprehension and application of specific systems of symbolic meaning. [...] Between what our body tells us and what we have to know in order to function, there is a vacuum we must fill ourselves, and we fill it with information (or misinformation) provided by our culture. [...] Our ideas, our values, our acts, even our emotions, are cultural products—products manufactured, indeed, out of tendencies, capacities, and dispositions with which we were born, but manufactured nonetheless. It is no different with men: they, too, every last one of them, are cultural artifacts.

› **Clifford Geertz**
*The Interpretation of Culture*

← Opposite
**Mongolia,** Kogo Kan,
Buriat cattleman

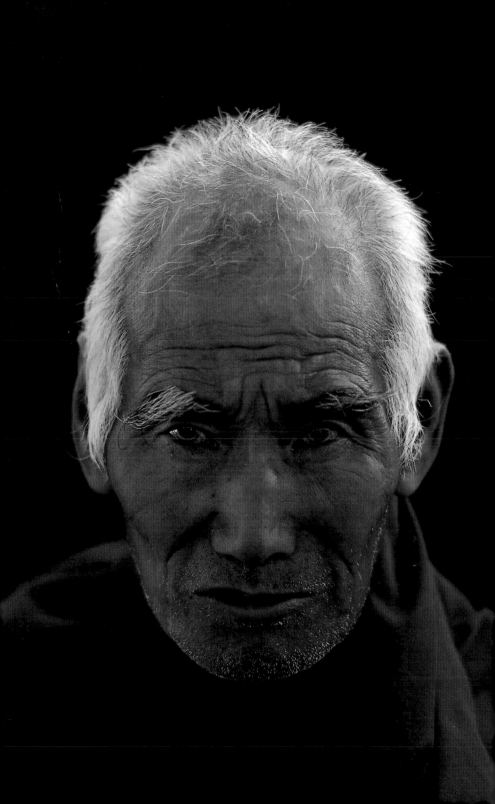

**The fairest thing we can experience** is the mysterious. It is the fundamental emotion, which stands at the cradle of true art and true science. He who knows it not and can no longer wonder, no longer feel amazement, is as good as dead, a snuffed-out candle. It was the experience of mystery—even if mixed with fear—that engendered religion. A knowledge of the existence of something we cannot penetrate, of the manifestations of the profoundest reason and the most radiant beauty, which are only accessible to our reason in their most elementary forms—it is this knowledge and this emotion that constitute the truly religious attitude.

› **Albert Einstein**
*The World As I See It*

← Opposite

**China-Tibet,**
Buddhist man

→ Following pages

**China-Tibet,**
Buddhist man

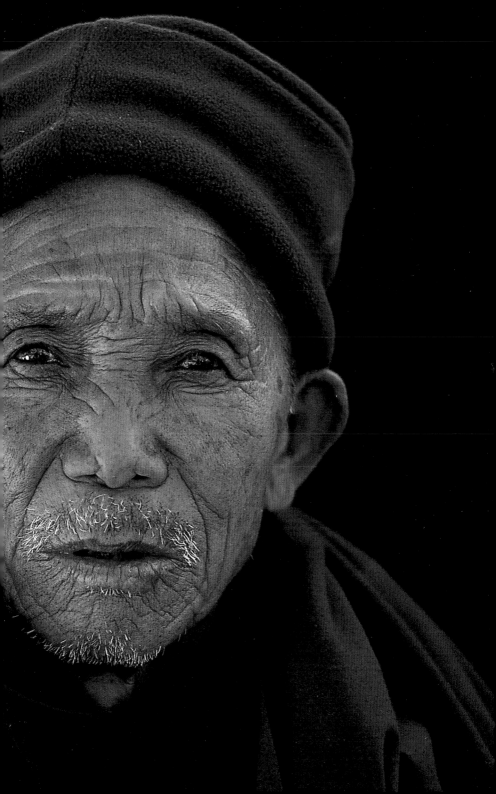

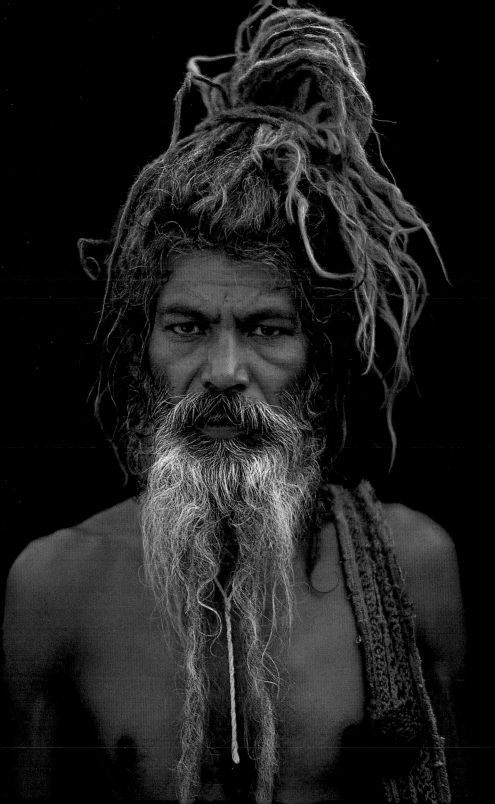

**Shared memory** is torn between two worldviews, which are manifested, in their pure forms, by science on the one hand and by myth on the other. Myth is populated with wondrous animals, supernatural interventions in nature and history, heroes and gods, and heroes on the way to becoming gods: all charmed and charming in the literal sense of the words. History, in contrast, may include bigger-than-life heroes in the metaphorical sense, or even charismatic people who aspire to belong to the two worlds. But the two worldviews are committed to different explanations, and to different notions of cause and effect. In the world as we know it today, the two worldviews coexist side by side. Indeed, with some people the two dwell within the very same soul, switching back and forth from one to the other.

› **Avishai Margalit**
*The Ethics of Memory*

← Opposite

**India,** Ujjain,
Sadhu Shiva worshipper

→ Following pages

**India,** Nagaland, Longwa,
Konyak woman

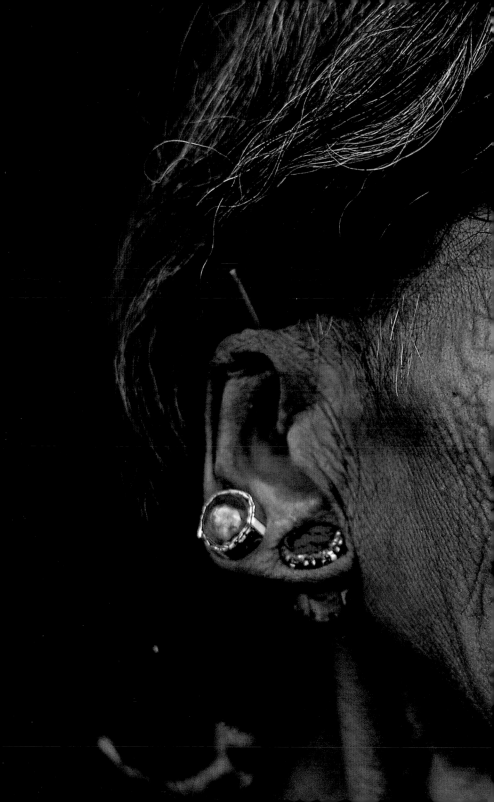

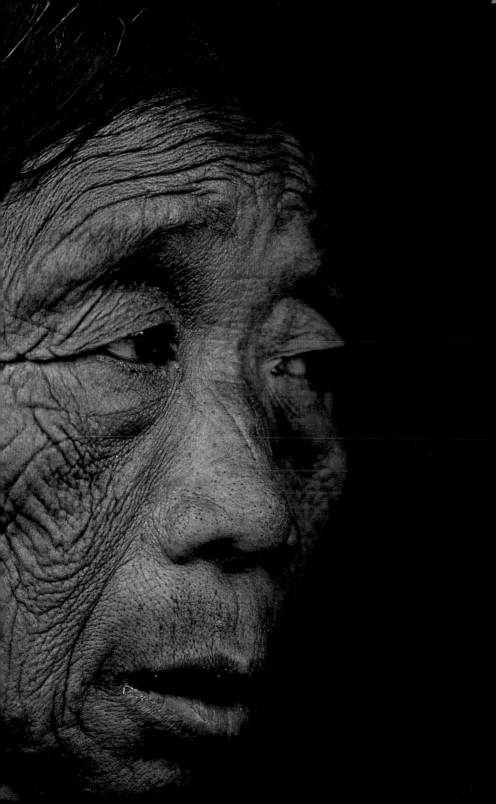

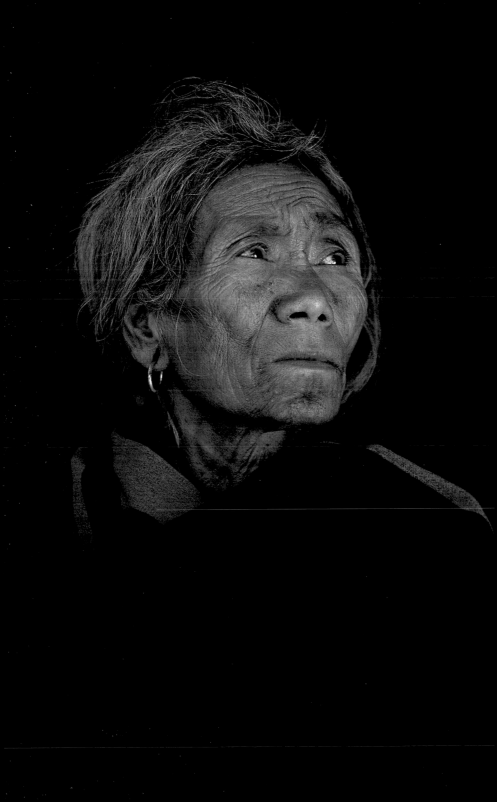

**Theory and practice** should be considered as a means for understanding our world, and should be judged exclusively on their accuracy, rigor, and relevance. How these tools are used, and for what purpose, should be the exclusive prerogative of social actors themselves, in specific social contexts, and on behalf of their values and interests. No more meta-politics, no more "maîtres à penser," and no more intellectuals pretending to be so. The most fundamental political liberation is for people to free themselves from uncritical adherence to theoretical or ideological schemes, to construct their practice on the basis of their experience, while using whatever information or analysis is available to them, from a variety of sources. In the twentieth century, philosophers have been trying to change the world. In the twenty-first century, it is time for them to interpret it differently.

› Manuel Castells
*End of Millennium*

← Opposite
**India,** Nagaland, Shangnyu,
Konyak woman

→ Following pages
**India,** Nagaland, Longwa,
Konyak man

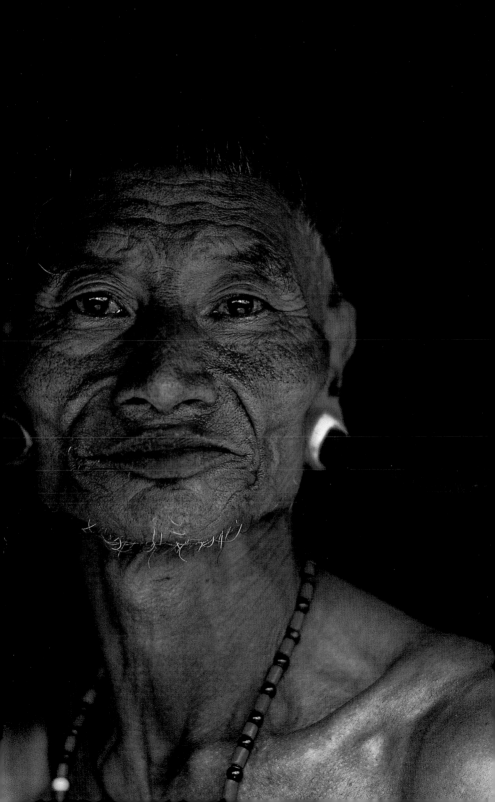

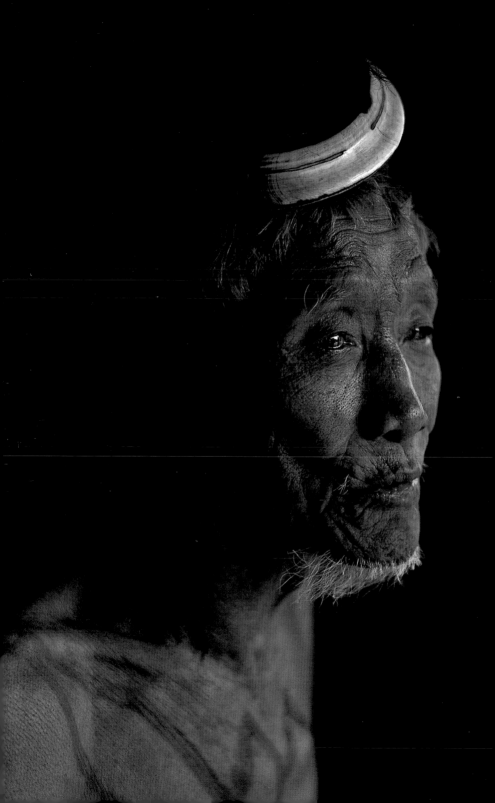

**The boundaries of the "normal"** are not fixed, but shift according to changes in scientific orthodoxies. [...] Yet in spite of the commitment of many scientists and academic philosophers to the materialist philosophy, most people remain unconvinced that they themselves are mere automata whose decisions and opinions are determined solely by physical causes in their brains. The commonsense idea is that our conscious selves are more than our brains. [...] The materialist theory goes against our own most immediate experience of ourselves and of others.

› **Rupert Sheldrake**
*The Sense of Being Stared At*

← Opposite
**India,** Nagaland, Shangnyu, Konyak chief

→ Following pages
**Peru,** Altiplano, Lake Titicaca, Uros woman

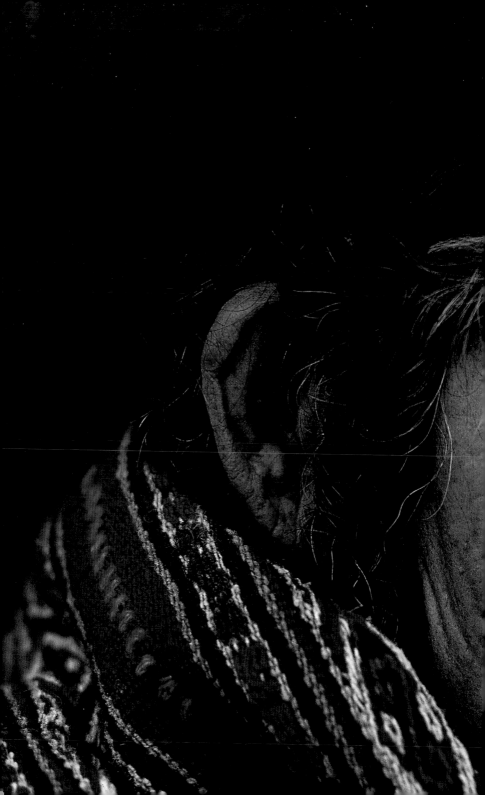

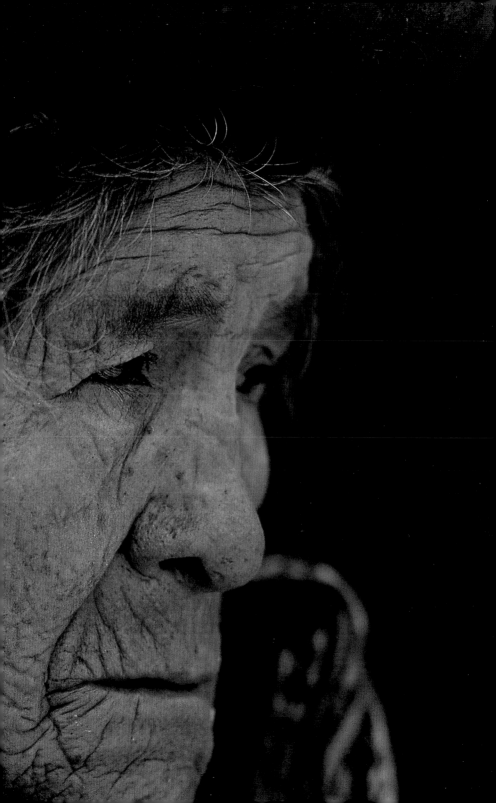

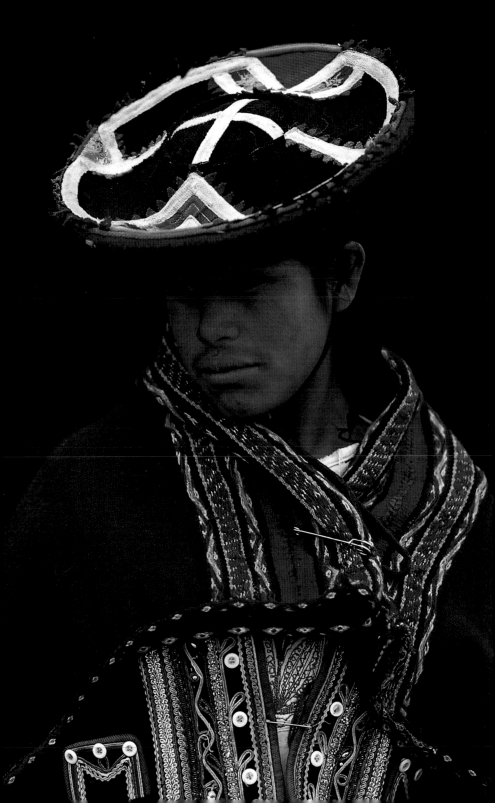

**The stranger is not the wanderer** who comes today and goes tomorrow, but is rather the person who comes today and stays tomorrow. He is, so to speak, the potential wanderer: although he has not moved on, he has not quite overcome the freedom of coming and going. He is fixed within a particular spatial group, or within a group whose boundaries are similar to spatial boundaries. But his position in this group is determined, essentially, by the fact that he has not belonged to it from the beginning, that he imports qualities into it, which do not and cannot stem from the group itself. [...] He is not radically committed to the unique ingredients and peculiar tendencies of the group, and therefore approaches them with the specific attitude of "objectivity." But objectivity does not simply involve passivity and detachment; it is a particular structure composed of distance and nearness, indifference and involvement. [...] Objectivity may also be defined as freedom: the objective individual is bound by no commitments which could prejudice his perception, understanding, and evaluation of the given.

› **Georg Simmel**
 *The Sociology of Georg Simmel*

← Opposite
**Peru,** Chincheros Market,
Quechua man

→ Following pages
**Peru,** Ollantaytambo,
Quechua woman

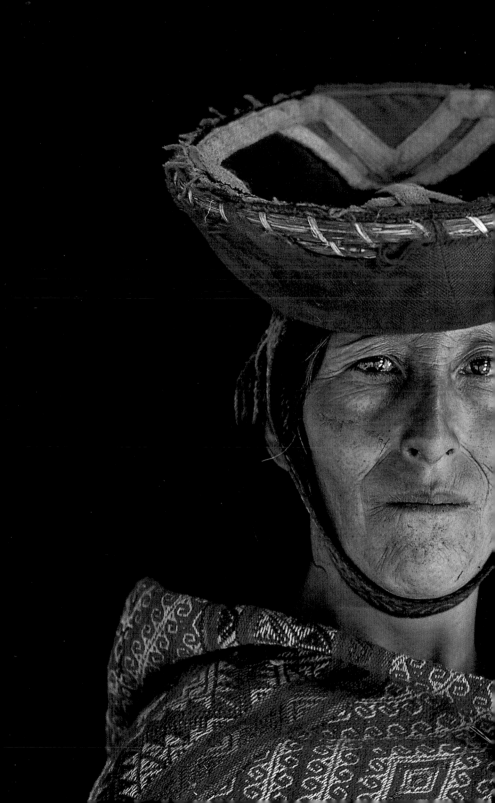

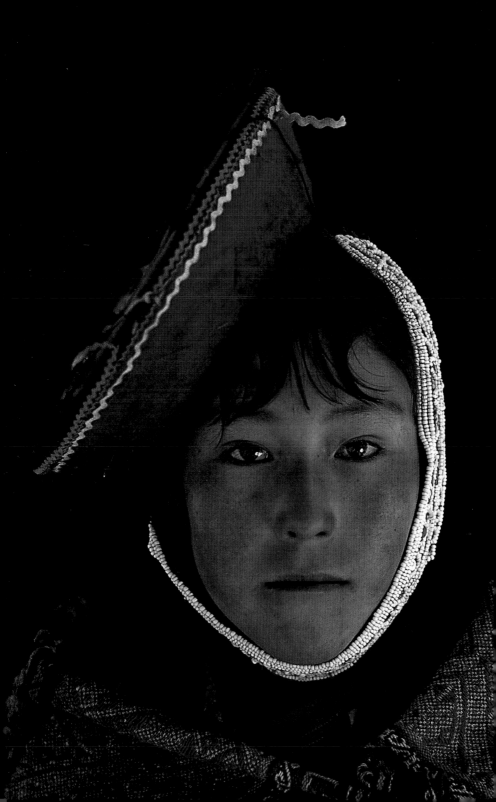

**If it is true that love** is the only sane and satisfactory answer to the problem of human existence, then any society which excludes, relatively, the development of love, must in the long run perish of its own contradiction with the basic necessities of human nature. Indeed, to speak of love is not "preaching," for the simple reason that it means to speak of the ultimate and real need in every human being. That this need has been obscured does not mean that it does not exist. To analyze the nature of love is to discover its general absence today and to criticize the social conditions which are responsible for this absence. To have faith in the possibility of love as a social and not only exceptional-individual phenomenon is a rational faith based on the insight into the very nature of man.

› **Erich Fromm**
*The Art of Loving*

← Opposite
**Peru,** Ollantaytambo,
Quechua woman

→ Following pages
**Peru,** Ollantaytambo,
Quechua child

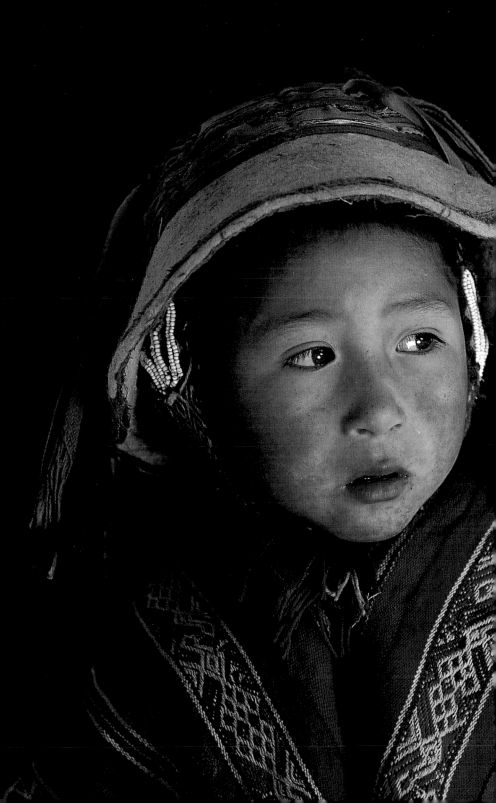

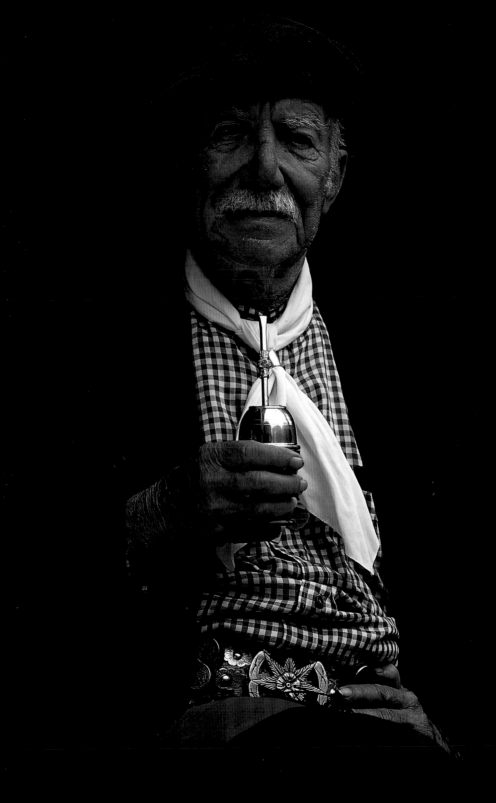

**Man has no specific identity** other than the *ability* to recognize himself. Yet to define the human not through any *nota characteristica*, but rather through his self-knowledge, means that man is the being which recognizes itself as such, that *man is the animal that must recognize itself as human to be human.* Indeed, Linnaeus writes that, at the moment of birth, nature has thrown man "bare upon the bare earth," unable to know, speak, walk, or feed himself unless all this is taught to him. He becomes himself only if he raises himself above man. *Homo sapiens*, then, is neither a clearly defined species nor a substance; it is, rather, a machine or device for producing the recognition of the human. The anthropogenic machine is an optical one constructed of a series of mirrors in which man, looking at himself, sees his own image always already deformed in the features of an ape.

› **Giorgio Agamben**
*The Open: Man and Animal*

← Opposite
**Argentina,** Pampa Húmeda, gaucho maté drinker

→ Following pages
**Argentina,** Pampa Húmeda, gauchos

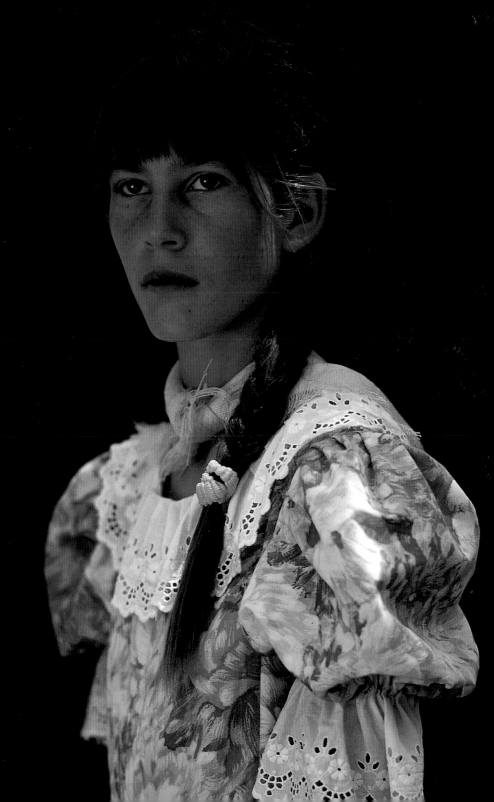

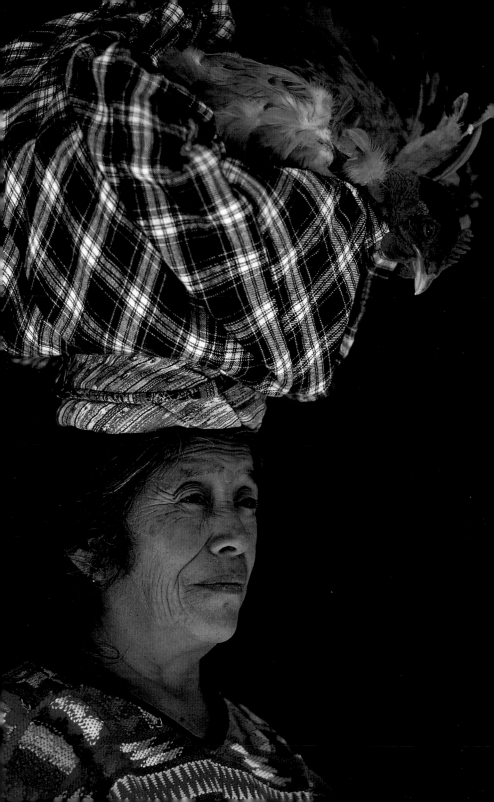

**Nothing we hold or do** in everyday life derives from us but rather from beings who are other to us, from a different species that established it in earlier times. Our only function is to preserve their inviolable legacy and to repeat their sacred teaching. […] The founding events and acts had already taken place, but they were at the same time destined to be endlessly perpetuated, both through rituals to revive them, and through filial piety demanding that the legacy be reproduced in every detail.

› Marcel Gauchet
*The Disenchantment of the World*

← Opposite                    → Following pages
**Guatemala,** San Andrés Itzapa     **Peru,** Lake Titicaca,
Market, Quiche woman           Uros woman

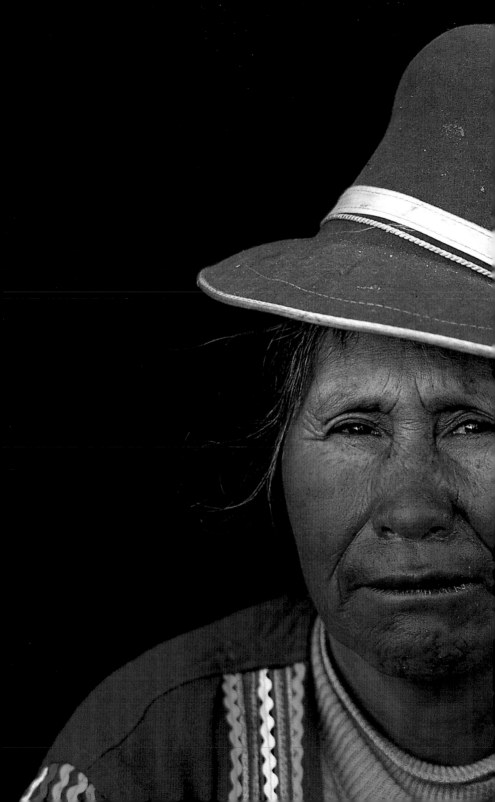

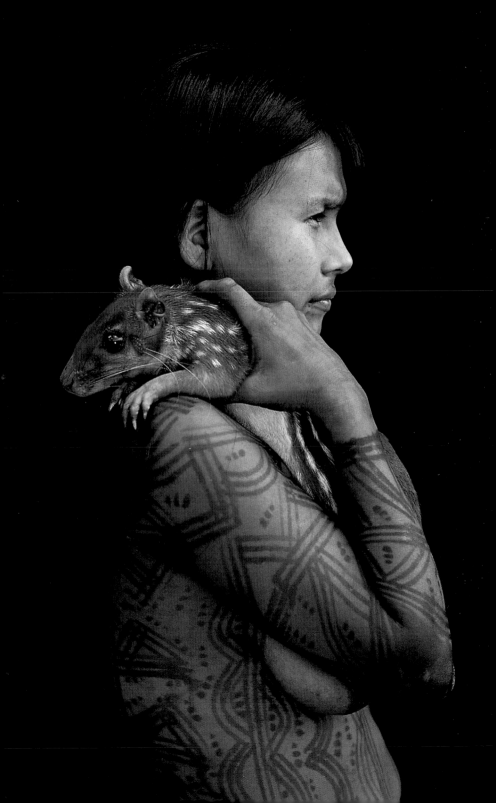

**Native American origins** are not a mystery to most Indian people. American Indian culture embodies a cornucopia of oral tradition to explain where they came from. These so-called origin myths address the most profound of human questions. Who are we? Why are we here? What is the purpose of life and death? What is our place in the world, in time, and in space? These are not questions that occur to primitive minds, nor do such ideas really address fact or reality. They deal with central issues of value and meaning. Myth is so powerful not only because it embodies cultural attitudes, but because origin myths shape such cultural attitudes toward fact and reality.

› Alvin M. Joseph, Jr.
  *The Native Americans*

← Opposite
**Panama,** Darién Province,
Embera woman

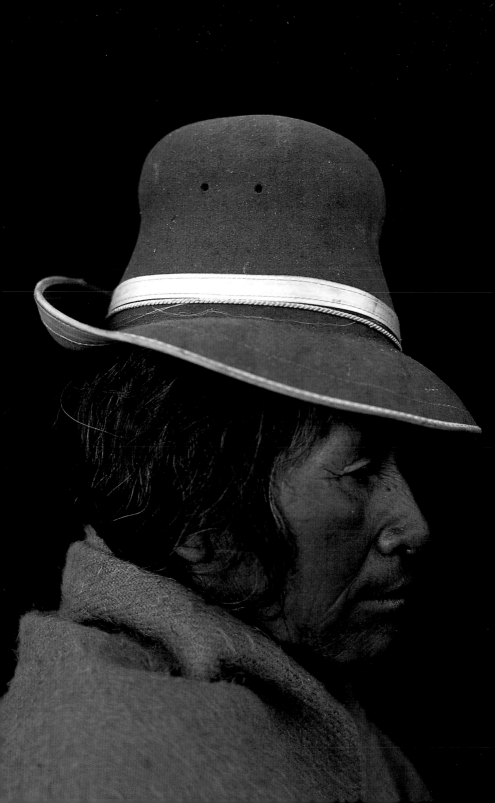

**There are, *a fortiori*, no primitive societies**
revealing humans in their pristine nakedness, as if they
had just sprung into existence, prior to any cumulative
civilizing effect on them and their surroundings by labor.
[...] A chasm separates us from our origins, one that
science only serves to widen by making increasingly
absurd conjectures about them. In fact, the most archaic
human remains we possess come from fully civilized
societies that clearly share a common history with us,
and which undoubtedly share the same set of opinions
as us. [...] The main similarity lies in the role of religion.
If we start from the point where the religious occupies
the entire social space, including whatever will be
subsequently taken over by the State, we can determine
the source of these societies' differences from, and simi-
larities to, our own.

› Marcel Gauchet
*The Disenchantment of the World*

← Opposite
**Peru,** Lake Titicaca,
Uros woman

→ Following pages
**Peru,** Raqchi,
Quechua woman

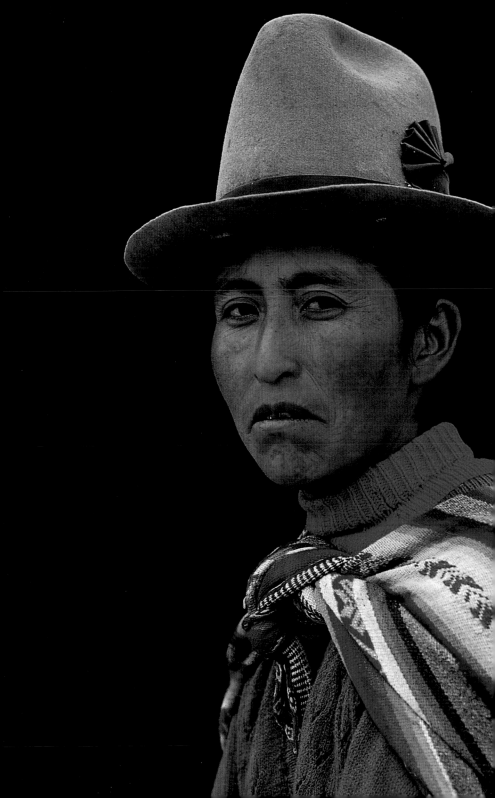

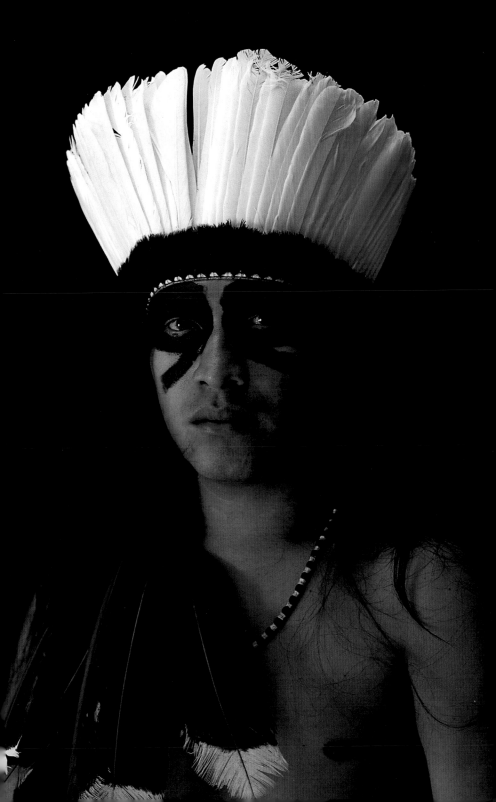

**The movement of humans** into social groups, the tendency of one social organism to swallow another, the rise of the meme, the increase in cooperation—all are ways in which the universe has ratcheted upward in degrees of order. But under the natural urge toward more intricate structures, higher planes of wonder, and startlingly new and effective forms of complexity, there is no moral sense. There is no motherly Nature who loves her offspring and protects them from harm. Harm, in fact, is a fundamental tool Nature has used to refine her creations. [...] But there is hope that we may someday free ourselves of savagery. To our species, evolution has given something new—the imagination. With that gift, we have dreamed of peace. Our task—perhaps the only one that will save us—is to turn what we have dreamed into reality.

› **Howard Bloom**
  *The Lucifer Principle*

← Opposite
**Brazil,** Amazon,
Bororo man

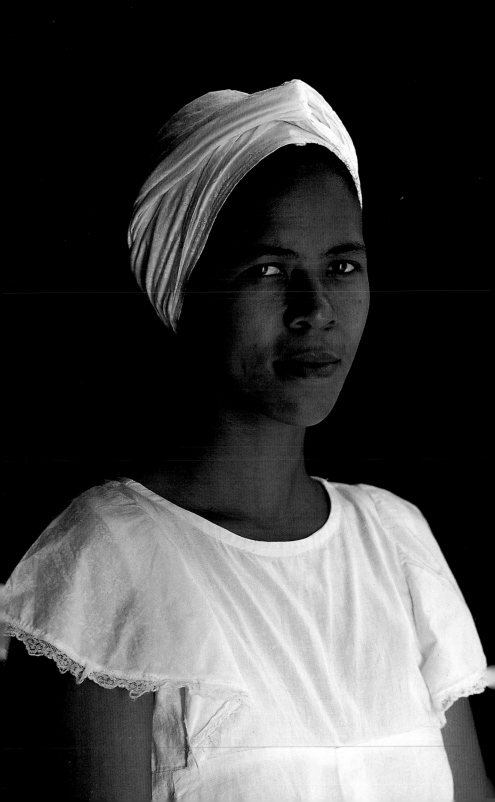

**Today, billions of *homo sapiens sapiens*** have invaded almost the entire planet and are even trying to travel beyond it. Are the organization and flexibility of the human brain still compatible with the evolution of an environment that it can control only very partially? Is a profound disharmony being established between the human brain and the world around it? We may well ask. The forms of architecture we enclose ourselves in, the working conditions we endure, the threats of total destruction with which we menace our like, the malnutrition we inflict on the majority of our fellows—do all these favor a balanced development and functioning of our brain? It is very doubtful. After destroying our environment, are we not now destroying our own brains?

› Jean-Pierre Changeux
*Neuronal Man: The Biology of Mind*

← Opposite
**Brazil,** Bahia,
Bahia woman

→ Following pages
**Brazil,** Salvador,
a lady from Candomble

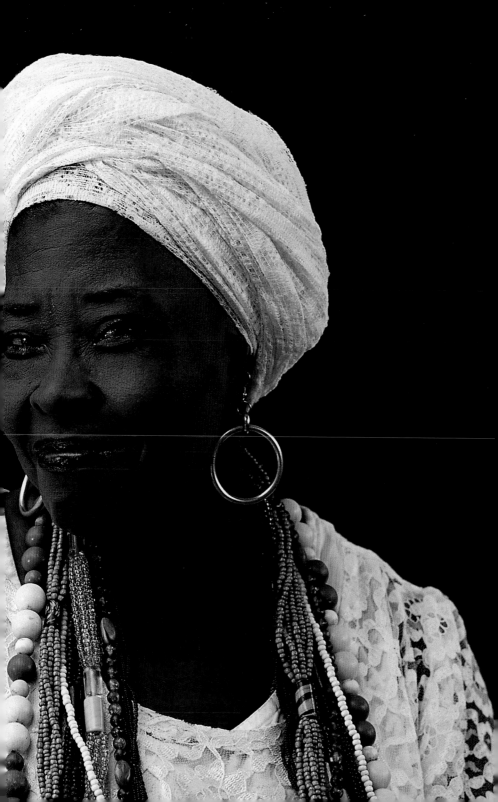

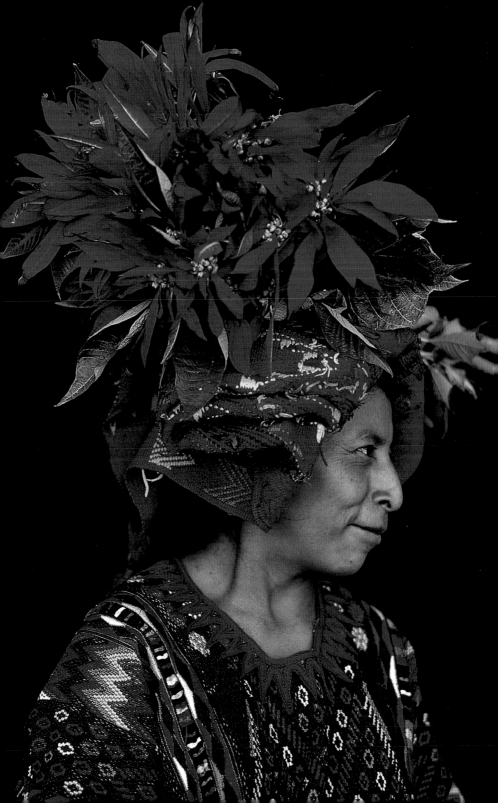

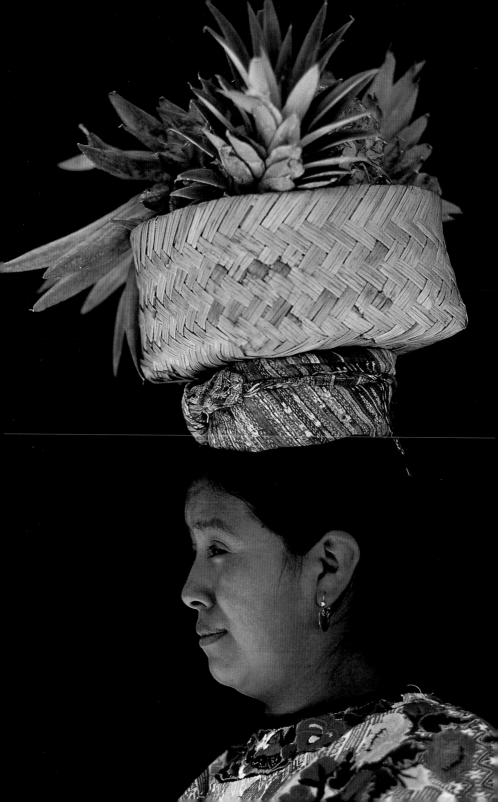

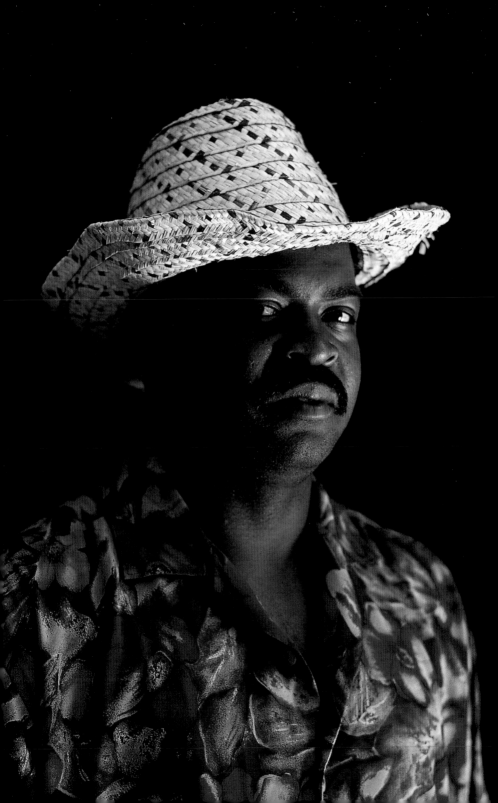

**The worldwide human population** is well over five billion and mushrooming. Modern transportation has made a mockery of distance and geographic barriers. Individuals are incomparably more mobile than ever before. Isolation of populations within our species is a thing of the past, while intermixing among peoples from all geographical areas is on the upswing. The result, without question, is that today the conditions for true evolutionary innovation within our species simply do not exist. We form a vast single population that straddles Earth; never ever, in the history of any species, have conditions been less propitious for the fixation of evolutionary novelties. And, short of some calamity, they won't be.

› **Ian Tattersall**
  *Becoming Human: Evolution and Human Uniqueness*

← Previous pages
**Guatemala,** Chichicastenango, Quiche woman (left);
**Guatemala,** San Andrés Itzapa, Quiche woman (right)

← Opposite
**Indian Ocean,** Rodrigues Island, Creole man

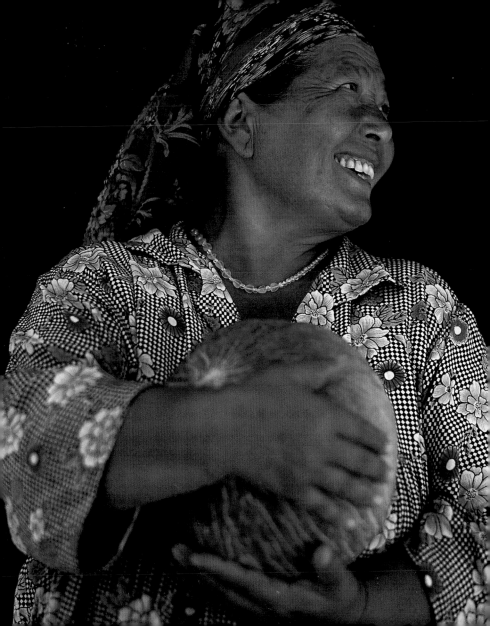

## Acknowledgments

To Faby-Zoé, Yasmine, Swann, Tom, Jeannine, Bernard, Mercédes, Florence, Crémilde, Sylvie, Andy, Pascal, Françoise, Jérôme, Mireille, Jill, Jean-Jacques, Anne, Ineke, Kathleen, Yves, Sébastien, Lau-lèo, Groseille, Richard, Laure, Pierre-Marie, Armelle, Cécilia, Pierre, Magali, Ariel, Micheline, Francis, Catherine, Yves, Marie-Christine, Auguste, Brigitte, Jean-Pierre, Caty, Milou, Jean-Marc, Hélène, Solange, Geneviève, Elie, Nina, Véro, Pascal, Laurence, Patrick, Valérie, Olivier, Marie-Lou, Isabelle, Muriel, Henri, Anne, Marc, Fabienne, Philippe, Ines, Michel, Joëlle, François, Paola, Jean-Chris, Nelly, Véronique, Jonathan, Saaga'ab, Neithonu, et al.

To all my friends, as well as to all those with whom I shared a moment of affection or complicity, be it for no more than a glance. I dedicate this paean to the diversity wherein each individual is significant, to all of those who created my existence and without whom, really, I would not be who I am. My thanks to Jean-Paul Chantraine, to Sylvie Pons, and to Nathalie Bec, without whom this work would not exist.

Patrick De Wilde: **www.patdewilde.com**

← Opposite
**Uzbekistan**

# Text credits

**Agamben,** Giorgio: *The Open: Man and Animal.* Trans. Kevin Attell. Stanford: Stanford University Press, 2004 [© 2005 by the Board of Trustees of the Leland Stanford Jr. University]. **Badinter,** Elisabeth: *Man/Woman: The One Is the Other.* Trans. Barbara Wright. London: Collins Harvill, 1989. **Bergson,** Henri: *Creative Evolution.* Trans. Arthur Mitchell. New York: Random House, 1944. **Bloom,** Howard: *The Lucifer Principle.* New York: The Atlantic Monthly Press, 1995. **Boas,** Franz: *Anthropology and Modern Life.* New York: Dover Press, 1962. **Castells,** Manuel: *End of Millennium.* Malden: Blackwell, 1998. **Changeux,** Jean-Pierre: *Neuronal Man: The Biology of Mind.* Trans. Laurence Garey. New York: Pantheon Books, 1985. **Cusa,** Nicholas of: *Selected Spiritual Writings.* Trans. H. Lawrence Bond. New York: Paulist Press, 1997. **Diamond,** Jared: *The Third Chimpanzee.* New York: Harper, 1992. **Einstein,** Albert: *The World As I See It.* Secaucus: Citadel Press, 1993. **Fromm,** Erich: *The Art of Loving.* New York: Perennial, 1999. **Gauchet,** Marcel: *The Disenchantment of the World.* Trans. Oscar Burge. Princeton: Princeton University Press, 1997. **Geertz,** Clifford: *The Interpretation of Culture.* New York: Basic Books, 1973. **Jacquard,** Albert: *In Praise of Difference.* Trans. Margaret M. Moriarty. New York: Columbia University Press, 1984. **Joseph,** Alvin M., Jr.: *The Native Americans.* Atlanta: Turner Publishing, 1993. **Kirshenblatt-Gimblett,** Barbara: *Destination Culture.* Berkeley: University of California Press, 1998. **Latouche,** Serge: *The Westernization of the World.* Trans. Rosemary Morris. Cambridge: Polity Press, 1996. **Leiris,** Michel: *Francis Bacon.* New York: Rizzoli, 1987. **Lévi-Strauss,** Claude: *Race and History.* Paris: UNESCO, 1958. **Maalouf,** Amin: *In the Name of Identity.* New York: Arcade Publishing, 2000 [© 1996 by Editions Grasset & Fasquelle; English translation © 2000 by Barbara Bray]. **Margalit,** Avishai: *The Ethics of Memory.* Cambridge: Harvard University Press, 2002. **Mead,** Margaret: *Male and Female.* New York: Perennial, 2001. **Morin,** Edgar: *Homeland Earth.* Creskill: Hampton Press, 1999. **Peacock,** James L.: *The Anthropological Lens.* Cambridge: Cambridge University Press, 2001. **Pollack,** Robert: *Signs of Life.* New York: Houghton Mifflin, 1994. **Sagan,** Carl, and Ann Druyan: *Shadows of Forgotten Ancestors.* New York: Ballantine Books, 1992. **Santayana,** George: *The Sense of Beauty.* New York: Barnes & Noble, 2005. **Sheldrake,** Rupert: *The Sense of Being Stared At.* New York: Crown Publishers, 2003. **Simmel,** Georg: *The Sociology of Georg Simmel.* Trans. Kurt Wolff. New York: Free Press, 1950. **Tattersall,** Ian: *Becoming Human: Evolution and Human Uniqueness.* New York: Harcourt Brace & Co., 1998. **Todorov,** Tzvetan: *Imperfect Garden: The Legacy of Humanism.* Trans. Carol Cosman. Princeton: Princeton University Press, 2002. **Vercors,** Jean: *You Shall Know Them.* Trans. Rita Barisse. Boston: Little, Brown and Co., 1953.